IMAGES
of Rail

COPPER COUNTRY RAIL

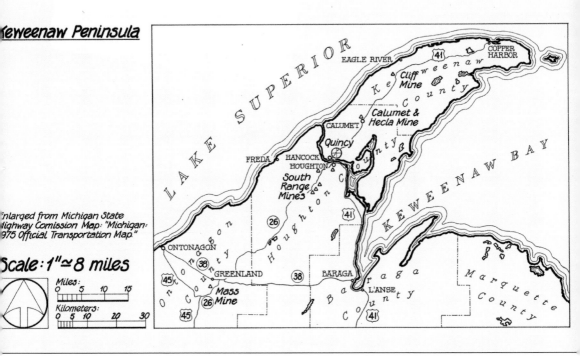

Keweenaw Peninsula

LAKE SUPERIOR

EAGLE RIVER
Cliff Mine
Keweenaw County
Calumet & Hecla Mine
CALUMET
Quincy
FREDA HANCOCK
HOUGHTON
South Range Mines
Houghton County
ONTONAGON
GREENLAND
Mass Mine
BARAGA
L'ANSE
Baraga County
KEWEENAW BAY
Marquette County

COPPER HARBOR

Enlarged from Michigan State
Highway Comission Map: "Michigan:
1975 Official Transportation Map."

Scale: 1" ≈ 8 miles

Miles:
0 5 10 15

Kilometers:
0 5 10 20 30

This modern map, produced by the Smithsonian's Historical American Engineering Record (HAER), documents the major mining areas of the copper district of Michigan's Keweenaw Peninsula and what was known as the South Range. (MTU Archives and Copper Country Historical Collections, Michigan Technological University.)

On the cover: One of the four Mineral Range Railroad 2-6-0 Moguls stands for its portrait with the train crew amid high snow piles outside Lake Linden in the early 1880s. The drifts, which are many feet high, show why huge wedge plows, such as the one on the front of the locomotive, were required. In this period and for many years to come, the lake-effect snowfall from Lake Superior dumped an average of 200 inches of snow on the area each season. In spite of the huge plow, frequently locomotives got seriously stuck and had to be dug out of the drifts by hand. (MTU Archives and Copper Country Historical Collections, Michigan Technological University.)

IMAGES
of Rail

COPPER COUNTRY RAIL

George E. Anderson and Richard E. Taylor

ARCADIA
PUBLISHING

Published by Arcadia Publishing
Charleston, South Carolina

Printed in the United States of America

Library of Congress Catalog Card Number: 2007923220

For all general information contact Arcadia Publishing at:
Telephone 843-853-2070
Fax 843-853-0044
E-mail sales@arcadiapublishing.com
For customer service and orders:
Toll-Free 1-888-313-2665

Visit us on the Internet at www.arcadiapublishing.com

CONTENTS

ACKNOWLEDGMENTS

This book seeks to tell this rich story of Copper Country railroads through a stunning collection of 230 pictures from various archival sources including the Houghton County Historical Society, Keweenaw County Historical Society, the Rudolph Maki collection, the Chuck Pomazal collection, the Michigan Technological University Copper Country Historical Archives, the National Park Service archives, the Smithsonian Institution, the Henry Ford, Superior View Studio/Jack Deo collection, the Albert W. Henning collection, the David D. Tinder collection, the Glen Marshall collection, and the authors' own collections. A special commemoration is due longtime friend and mentor Albert W. Henning who unfortunately passed away about the time this book was being conceived.

INTRODUCTION

Since 1870, when Louis Agassiz, president of the Calumet and Hecla Mining companies, purchased the first 49-inch-gauge steam locomotive in Michigan's Copper Country to move ore from the mine to the stamp mill, railroads and the development of the first major mining boom in America's history have been intimately linked. Before the coming of railroads, ore and native copper from the mines had to be shipped via oxcart to the lakeshore and sent to Detroit, Buffalo, and even Boston, Massachusetts, for final processing. The entire area was dependent on the shipping of essential supplies on stormy Lake Superior for its survival. From November until May, shipping ceased. For example, in the 1850s, on a trip to the copper regions for *Harper's Weekly*, Horace Greeley related how they had to exit their boat for the shore on the edge of an ice sheet covering the surface of Eagle Harbor in early May, along with an entire shipment of cattle.

The Marquette, Houghton and Ontonagon Railroad, which began in the Marquette iron range in the 1860s, pressed westward arriving in Houghton in the late 1870s, and Ontonagon by 1880, opening the region to the rest of the nation and its goods and services. At the same time, the Calumet and Hecla Mining Company built the Hecla and Torch Lake Railroad (49-inch gauge) and three other major narrow-gauge (36 inch) railroads, the Mineral Range Railroad (1873), the Hancock and Calumet Railroad (1876), and the Quincy and Torch Lake Railroad (1880), which began to serve the mines and citizens of the Copper Country. By 1899, the South Range (south of Houghton) was served by the Copper Range Railroad, built by the Copper Range Mining Company and with joint operating relations with the Milwaukee Road (Chicago, Milwaukee and St. Paul Railroad). In addition to the Class 1 common carriers that reached the area, there were upwards of over 50 other small industrial and logging roads for which there is a rich photographic record. Houghton County also supported an extensive trolley and interurban electric line, the Houghton County Traction Company, which began operating in 1900 and closed in the early 1930s as the mining industry declined during the Great Depression.

From simple beginnings of the 1870s to the complex rail network of 1900, the decline of the copper industry spelled a continuing retreat of the railroads until 1978, when no more trains entered the copper region. With abandonment in 1976 of the Houghton tracks of the Soo Line Railroad (former Mineral Range Railroad and Duluth, South Shore and Atlantic Railroad), the Copper Country came full circle and without a viable railroad service. Still, fascination with the rich railroad heritage, the Rails to Trails conversion of right-of-ways, and the mining history preserved by the Keweenaw National Historic Park have encouraged a continued public interest in the railroad history of the area.

One

THE FIRST RAILROAD

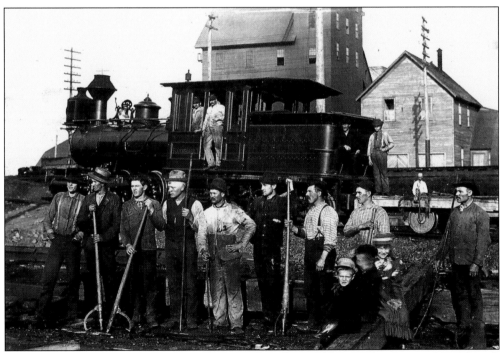

In this magnificent photograph with a Calumet and Hecla Mining Company (C&H) rock house in the background, the Hecla and Torch Lake (H&TL) No. 5 *Raymbault*, a 0-6-4T Mason Bogie built in May 1882, works right alongside the timber crew with their picks and peaveys. This was a good assignment for the surface crew, since the houses were clustered around the mines they worked right in town rather than some remote location out in the woods. (George E. Anderson collection.)

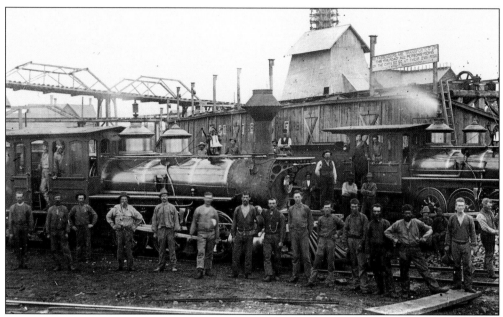

A large crew of mechanics and hostlers stands in front of H&TL No. 3 *Torch Lake* (left) and No. 2 *Calumet* (right) with the C&H mine rock house in the center background. The *Calumet* looks as if it is ready to get underway as its pressure valve is giving off a plume of steam. (MTU Archives and Copper Country Historical Collections, Michigan Technological University.)

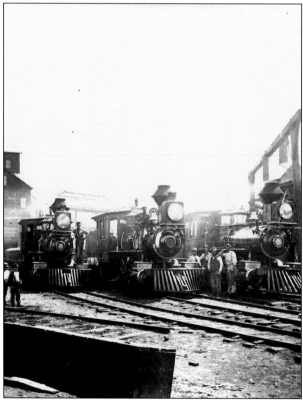

Three of the 49-inch-gauge H&TL Mason Bogie locomotives stand outside the old wooden engine house for their portrait. From left to right, they are No. 5, the *Raymbault* from 1882; No. 4, the *Red Jacket* from 1880; and No. 3, the *Torch Lake* from 1873. (MTU Archives and Copper Country Historical Collections, Michigan Technological University.)

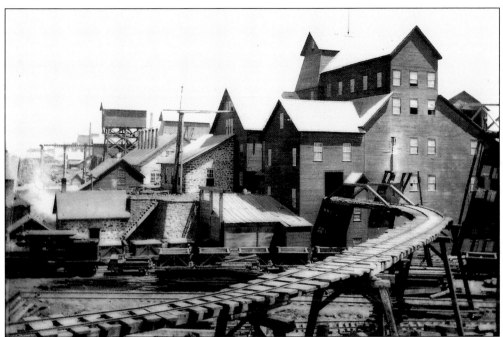

A long, curved trestle leads out from the C&H rock house in this view from 1879 looking up Mine Street in Calumet. The Mason Bogie engine pulls a string of little four-wheel rock jimmies through the scene with the ever-present idler car between the engine and the rock cars. These are the early rock cars with just a single vertical brace at the center of the side. (MTU Archives and Copper Country Historical Collections, Michigan Technological University.)

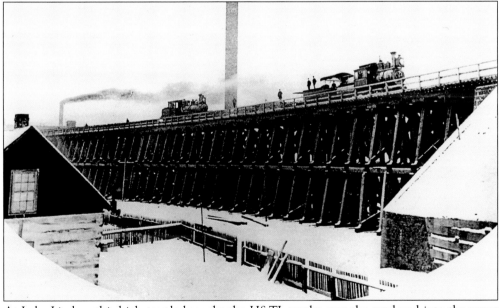

At Lake Linden, this high trestle brought the H&TL tracks over the road and into the upper level of the mill structures. Perched on top of the trestle are two engines of the H&TL. They are one of the two larger 0-6-4T Mason Bogies (left) and one of the two Baldwin camelback 2-8-0 Consolidations (right), all of them built in the 1880s. (George E. Anderson collection.)

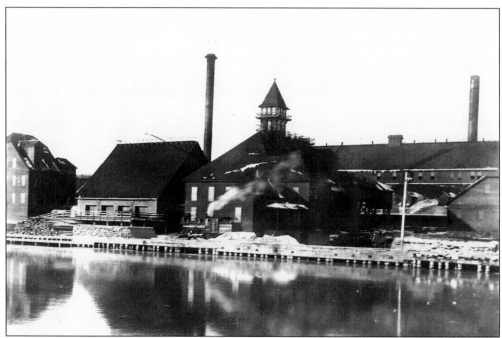

Looking down by the docks at Lake Linden, Mason Bogie No. 5, the *Raymbault*, is moving along between the piles of lumber and the C&H sand wheel house and pump house with the Hecla mill looming large in the background. The engine still sports its gold stripes and lettering applied at the Mason factory in 1882. Later photographs of this area show the water completely displaced by stamp sand. (George E. Anderson collection.)

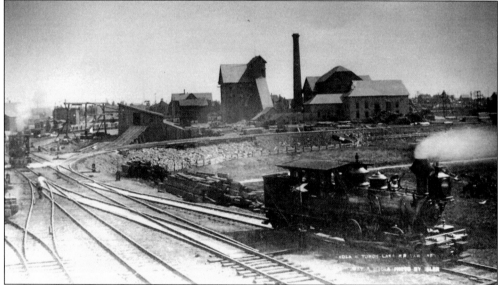

In this Adolph F. Isler photograph of the H&TL yards, a cluster of buildings can be seen, including C&H No. 2 rock house and the powerhouse with its tall brick stack in the background. There are three Mason Bogies closer to the camera and a camelback Consolidation in the left distance pulling a string of small four-wheel rock cars curving around behind the rock house. (George E. Anderson collection.)

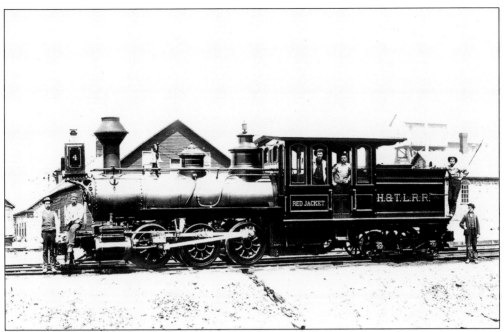

On April 28, 1880, the Mason Machine Works completed the third Mason Bogie for the H&TL. It became H&TL No. 4, the *Red Jacket*, a 49-inch-gauge 0-6-4T that bore Mason builders number 622. Red Jacket was the name of a prominent Native American chief and also the name of the city of Calumet at that time. (George E. Anderson Collection.)

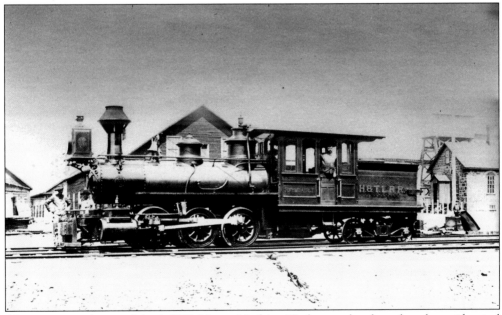

About two years later, on May 1, 1882, Mason Machine Works completed another almost-identical engine, which became H&TL No. 5, the *Raymbault*, a 0-6-4T that bore Mason builders number 681. The *Raymbault* was named for the Jesuit missionary Charles Raymbault (1602–1642), who journeyed up the lakes to Sault Ste. Marie with Fr. Isaac Jogues in 1641. They were probably the first Europeans to see the waters of Lake Superior. (George E. Anderson collection.)

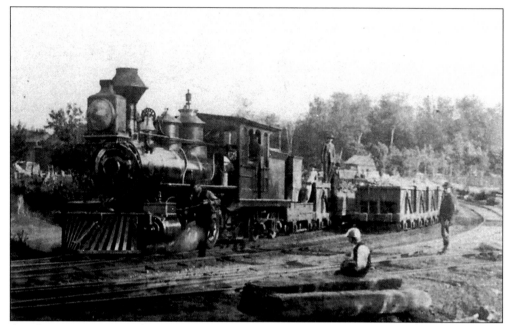

Another in-service view shows a Mason Bogie posing for the camera while a crewman performs his duty "oiling around." This looks like the *Raymbault*, but it is hard to tell because H&TL engines were not prominently marked. Notice the idler car between the high tender deck of the locomotive and the low end beam of the rock cars. (Superior View Studio/Jack Deo collection.)

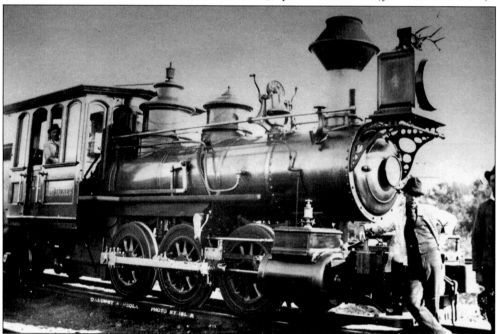

Here is a good look at Mason Bogie No. 4, *Red Jacket*, in service at a later date. The proud crew has attached a set of antlers to the top of the headlamp, which was a common practice on logging railroads in the woods, but a little more unusual to see on an industrial railroad in a more urban setting. (George E. Anderson collection.)

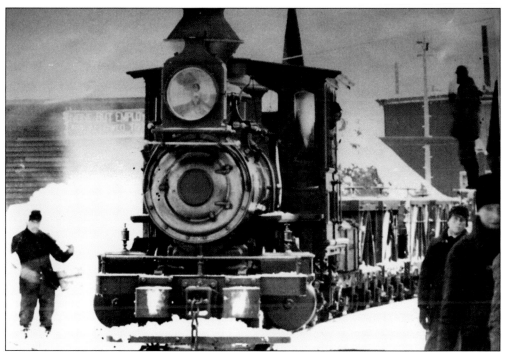

This Mason Bogie appears to have a round builders plate on the side of the smoke box, so it is probably the No. 5 *Raymbault* from 1882. The engine is followed by a mixed string of cars beginning with an idler car and then a pair of the first-generation cars with a single vertical center brace, followed by the slightly wider second-generation cars with two vertical center braces. (Albert W. Henning collection.)

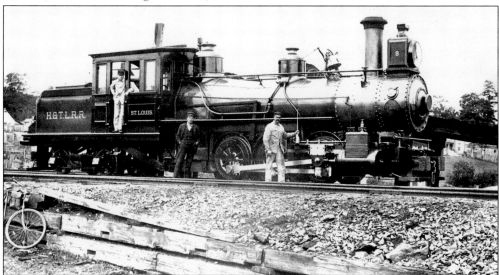

In 1887, the H&TL went back to Mason Machine Works and ordered two additional Mason Bogies, the *Schoolcraft* and the *St. Louis* seen here still fresh from the builder. While they were still 0-6-4T wheel arrangement like the previous bogies, they were larger engines with 45-inch drivers and an extended smoke box. Mason Machine Works completed the *St. Louis* on July 28, 1887, as construction number (C/N) 748, among the last Masons built. (Albert W. Henning collection.)

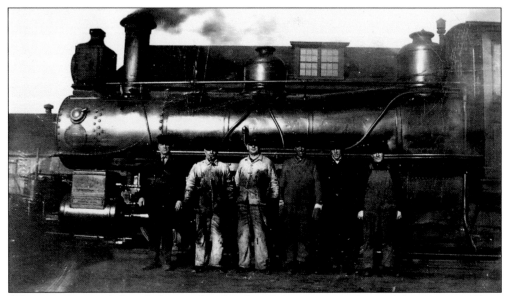

All steamed up and the whole crew has lined up for a picture in front of their engine. There is the conductor, the fireman, the engineer, the brakeman, the dispatcher, and the switchman, with one of the larger Mason Bogies behind them. The road numbers are no longer visible on the headlamp or sand dome, so it is not known whether this engine is the *Schoolcraft* or the *St. Louis*. (George E. Anderson collection.)

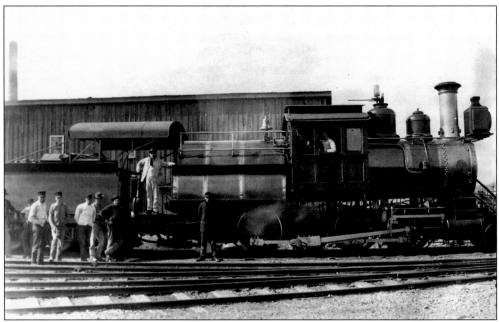

The *Manitou* was a Baldwin 2-8-0 camelback Consolidation that was built in 1886 as the H&TL No. 7 carrying builders number 8199. This engine and its sister engine, No. 6, the *Kitchigami* (builder's number 7709), were both later rebuilt with Belpaire fireboxes and served on the railroad until being scrapped at the end of World War II, the *Kitchigami* in 1944 and the *Manitou* in 1945. (Superior View Studio/Jack Deo collection.)

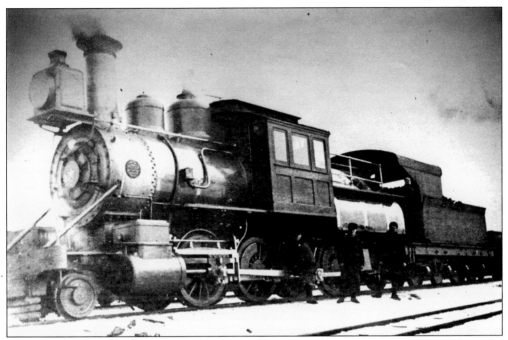

These camelbacks, among them the *Manitou*, marked a departure for the H&TL from the all-Mason roster and are the only two narrow-gauge camelbacks that were ever built. The wide Wooten firebox burned anthracite hard coal requiring large grates, moving the cab to the front of the firebox. The tender is fitted with a roof and side curtains to protect the fireman from the harsh winter weather. (George E. Anderson collection.)

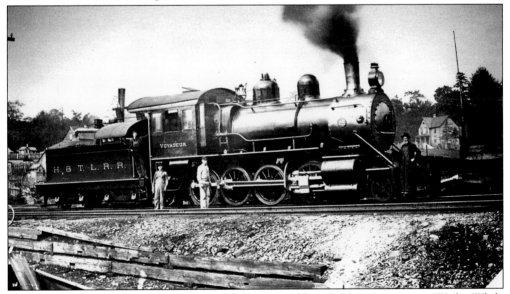

In 1900, a Vauclain compound 2-8-0 Consolidation arrived from Baldwin Locomotive Works. While the H&TL did not see fit to repeat the compound cylinders seen on the *Voyageur*, it must have liked the Belpaire firebox, because two more were ordered from Baldwin to rebuild the two Wooten firebox anthracite hard coal burning camelbacks into much more conventional appearing engines with the cabs moved back behind the new fireboxes. (Albert W. Henning collection.)

17

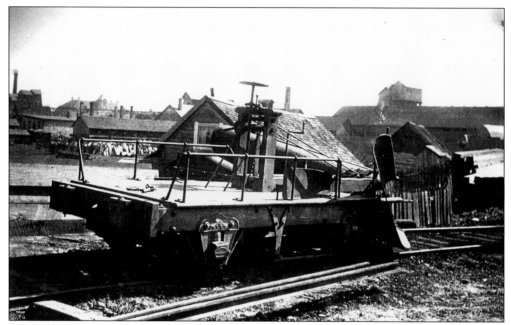

All the railroads operating in the Keweenaw Peninsula needed equipment to keep the rails clear during the long winter months, and the H&TL was no exception. This small four-wheel plow with the large snow blade was probably made in the company shops from one of the early rock cars, judging by the fancy cast-iron pedestals that are the same as were used on the rock cars. (Albert W. Henning collection.)

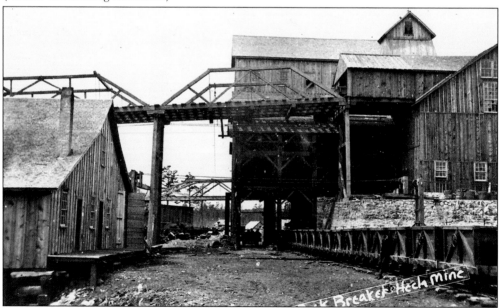

This string of early four-wheel rock cars lined up at the Hecla Mine under the rock breaker are the first-generation cars, distinguished by the single vertical side brace visible at the center of the car as well as the fancy cast-iron pedestals supporting the axels. These cars appear in photographs from 1868 but may not have been the original cars from the opening of operations in 1866. (George E. Anderson collection.)

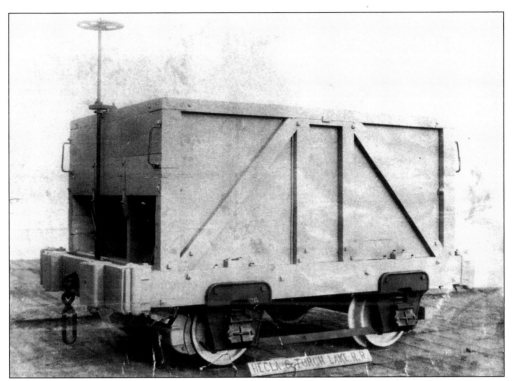

This is the builder's photograph of a 49-inch-gauge rock car that was constructed for the H&TL as the placard on the ground states. Evidence suggests that it was made in Detroit by one of the companies that became part of American Car and Foundry in 1899. Unfortunately the photograph gives no information concerning the date, the builder, or the number of cars ordered. (George E. Anderson collection.)

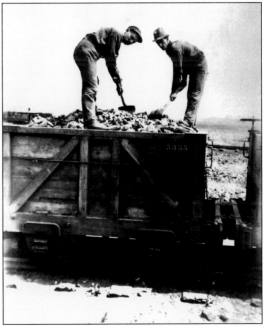

In this later photograph of the car in use, some of the modifications can be noted. The brake staff has been shortened enough to be operated by a crewman standing on the end beam, a truss rod has been added to the car side to keep it from bowing out, and a four-digit number has been stenciled on the side of the car, suggesting that the railroad had many rock cars of this style. (George E. Anderson collection.)

In 1890, the C&H ordered from E. D. Leavitt a steel depressed center "boiler car" as they called it since its purpose was to deliver large boilers to any point on the property. It came equipped with three sets of six-wheel trucks so that it could operate on standard gauge tracks and on the 49-inch-gauge tracks at the mines, as well as the 36-inch-gauge tracks down at the mill. (George E. Anderson collection.)

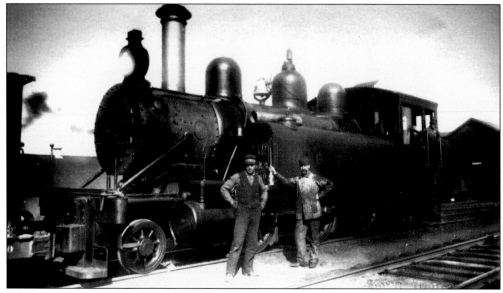

In 1896, the H&TL bought a pair of side-tank engines from Baldwin Locomotive Works. They were the *Allouez* No. 10, a 2-6-2T Baldwin No. 14793 shown here, and the *Ishpeming* No. 11, also a 2-6-2T Baldwin, No. 14794. Because it was an industrial short line without any passenger or long-haul requirements, the H&TL seemed to prefer tank-type locomotives like these Baldwins and the earlier Mason Bogies. (Albert W. Henning collection.)

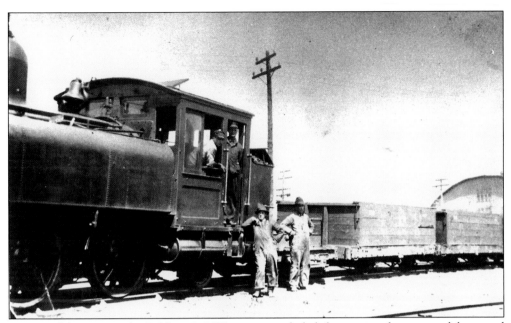

Later modifications to the Baldwin 2-6-2T engines included eliminating the rear sand dome and moving the bell to the former location of the dome and the addition of an air tank under the cab for the brake system. Here the often-present idler car can be seen between the engine and the rock cars, which may have been used to carry pure copper nuggets that had come up from the mine. (Albert W. Henning collection.)

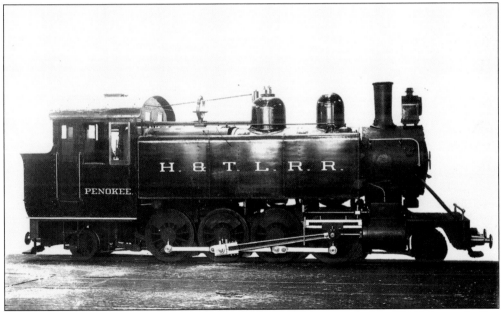

H&TL engine No. 15 *Penokee* was a Baldwin 2-8-2T built in 1902 as the No. 20163. It was the first of that wheel arrangement, which became known as the Calumet type, the only narrow-gauge engine to have an engine type named after it. The *Penokee* was the last 49-inch narrow-gauge engine purchased by the H&TL, as it had standard gauged when it ordered new engines in 1907. (George E. Anderson collection.)

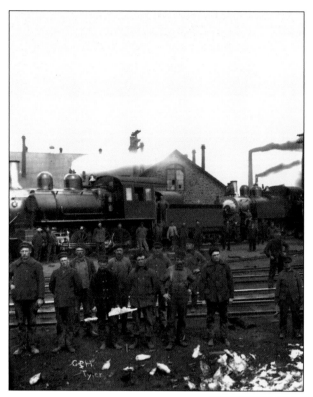

In this O. F. Tyler photograph from about 1903, a group of H&TL employees pose with the stone roundhouse in the background. Although no names or numbers are apparent on the locomotives, they are most likely the former camelback, rebuilt into a more normal 2-8-0 Consolidation (left), named *Manitou*, and the 2-8-2T Calumet type, named *Penokee* (right). (MTU Archives and Copper Country Historical Collections, Michigan Technological University.)

As is shown in the photograph above, a group of railroad workers poses in front of their charges. In this view are seen, from left to right, the 2-8-2T *Penokee* again, then the 1882 Mason Bogie *Raymbault*, with the larger 1887 Mason Bogies *St. Louis* and *Schoolcraft* on the right. Both of these photographs were taken by O. F. Tyler at the same time in the early 1900s. (MTU Archives and Copper Country Historical Collections, Michigan Technological University.)

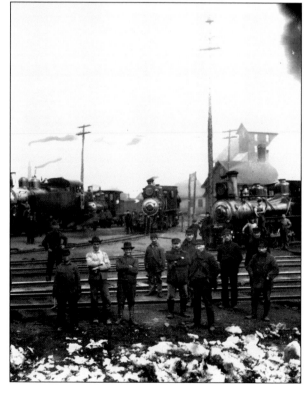

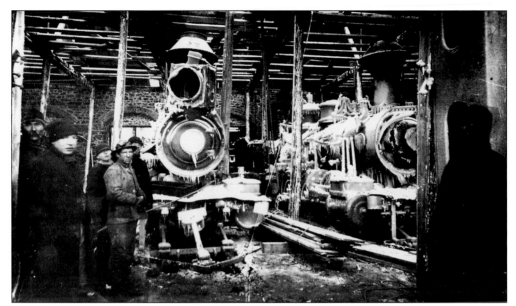

The forlorn remains of two Mason Bogies sit in the H&TL engine house after this fire in about 1904. The round builder's plate seen on the engine on the right suggests that it is the No. 5 *Raymbault*. The *Torch Lake* on the left was the first Mason Bogie rebuilt to standard gauge and was returned to service in 1906. The *Red Jacket* and *Raymbault* followed soon after and were not scrapped until 1942. (Albert W. Henning collection.)

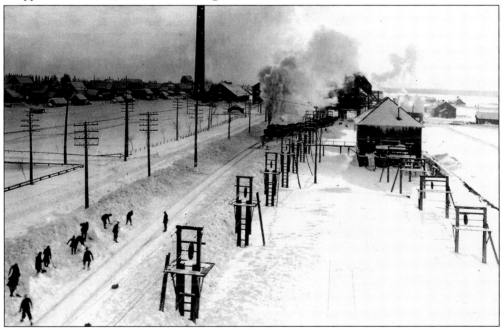

One of the two 1896 Baldwin Locomotive Works side-tank engines leads a northbound string of standard-gauge rock cars in this post-1910 view. The cars appear to be loaded with coal for the C&H boiler houses that are spread out along Mine Street here in Calumet. The crew on the lower left is working hard with hand shovels to move the snow back and keep it from drifting across the tracks. (George E. Anderson collection.)

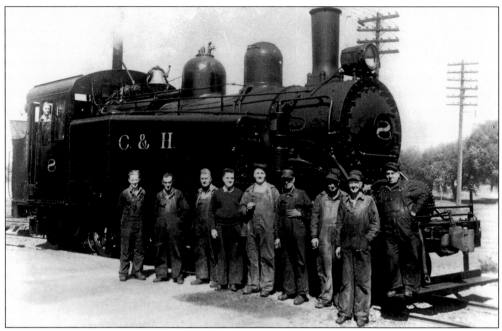

C&H engine No. 8, the *Roberval*, was a Baldwin 2-8-2T built to standard gauge and was the first of three new engines delivered in 1907 as the railroad was in the process of converting to standard gauge. The crew shown here includes, from left to right, Happy Vivian in the cab, Archie Othote, Joe Ragina, Charlie Manniko, Norman LaBonte, Herman Anderson, Jim Edwards, Bill Barker, Fred Climas, and Steve Valli. (George E. Anderson collection.)

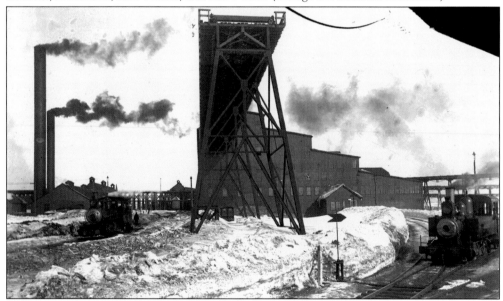

Seen here are the C&H mills at Lake Linden, looking up at the trestle and the south end of the Hecla Mill. The engine on the left is one of the H&TL 0-6-4T 49-inch-gauge Mason Bogies, while the other engine on the far right appears to be one of the 49-inch-gauge Porter 2-6-2Ts, either the 1899 *Montreal* or the 1901 *Bete Gris*. (MTU Archives and Copper Country Historical Collections, Michigan Technological University.)

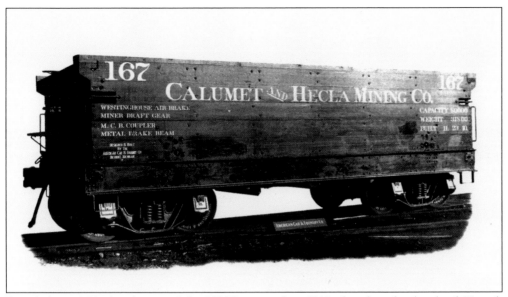

Founded in 1866, the charter of the H&TL expired in 1910, therefore this batch of 30 rock cars ordered on July 19, 1910, no longer carried the H&TL lettering as seen on previous cars but reverted to the corporate name, "Calumet and Hecla Mining Co." These were 24-foot cars completed by American Car and Foundry in Detroit on November 23, 1910, as lot No. 6033. (George E. Anderson collection.)

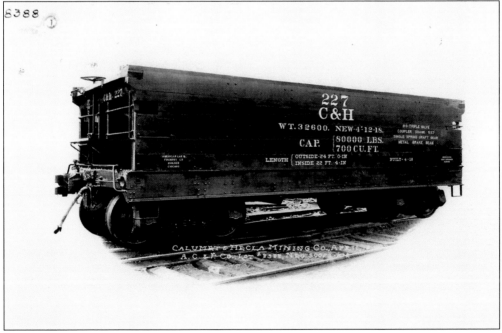

On this later group of C&H rock cars, markings can be seen that have been simplified again to show just the number and C&H centered on the car side. As earlier cars were repainted, this standardized format was adopted. This order, placed on March 31, 1917, was for 50 rock cars, still 24 feet in length, that were completed by American Car and Foundry in Chicago on April 12, 1918. (George E. Anderson collection.)

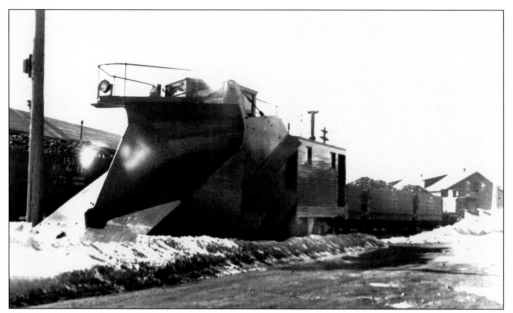

The C&H winged Russell snowplow sits on a siding on a sunny winter morning in Calumet. A train of American Car and Foundry eight-wheel rock cars sits behind it with full loads of coal and one of the little C&H four-wheel bobber cabooses on the far right in the distance. (MTU Archives and Copper Country Historical Collections, Michigan Technological University.)

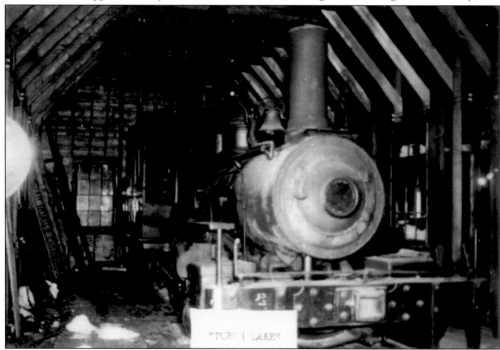

Like the proverbial Corvette in a barn, the *Torch Lake* is the only Mason Bogie in the world to survive the patriotic scrap drives of World War II. It languished in a shed in Ahmeek, until it was brought out of hibernation for the C&H centennial celebration in 1966. It was then donated to the Henry Ford and has been operating at Greenfield Village since 1970. (George E. Anderson collection.)

Two

MASS COPPER
MINE ROADS

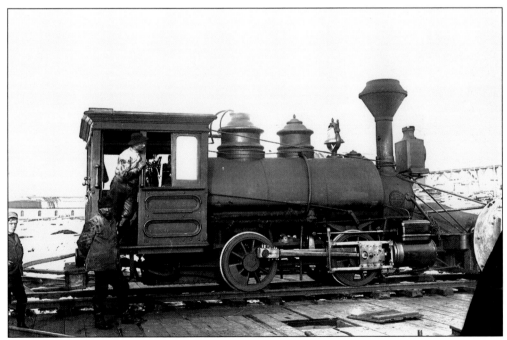

The Atlantic and Lake Superior Railroad engine No. 2 was the *P. R. Roberts* and was a Baldwin 0-4-0T built in February 1875 as C/N 3692. The engine went through many changes over the years, including a revised cab and addition of a trailing truck and the removal of the saddle tank. Finally it was rebuilt to a standard gauge 0-4-2T in 1895 but still retained its fluted domes. (MTU Archives and Copper Country Historical Collections, Michigan Technological University.)

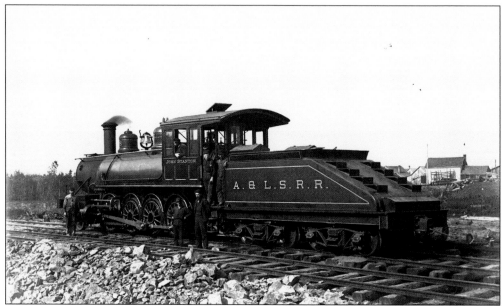

This 2-8-0 Consolidation, named the *John Stanton*, was built by Baldwin Locomotive Works in August 1894 as C/N 14060 and was one of the prime movers on the Atlantic and Lake Superior Railroad. It was unusual in that it had a slope-back switcher tender to accommodate better visibility for the crew when shuffling rock cars. (MTU Archives and Copper Country Historical Collections, Michigan Technological University.)

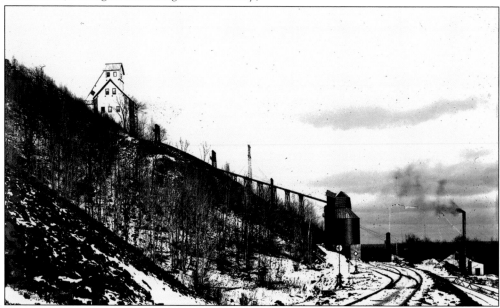

Michigan Mine Shaft C, the former Minesota Mine near Rockland, was reopened in 1905 by the owners of the Atlantic Mine known as the "Stanton group." The Copper Range Railroad picked up cars here on the Mineral Range Railroad's South Range branch at Peppard and hauled them to the Atlantic Mine. The ore then went to Redridge and the Atlantic mill on the Atlantic and Lake Superior Railroad. This operation continued until 1916. (MTU Archives and Copper Country Historical Collections, Michigan Technological University.)

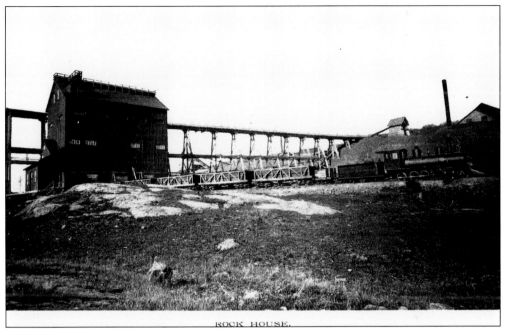

ROCK HOUSE.

This little 2-8-0 Consolidation was built by Baldwin as C/N 6749 in May 1883 for the Conglomerate Mining Company and is seen here on the Lac LaBelle and Calumet Railroad as it pulls a string of three-foot-gauge, Z-braced rock cars away from the Delaware Mine. Some of these cars are still on display at the Quincy No. 2 Shaft in the Keweenaw National Historic Park. (MTU Archives and Copper Country Historical Collections, Michigan Technological University.)

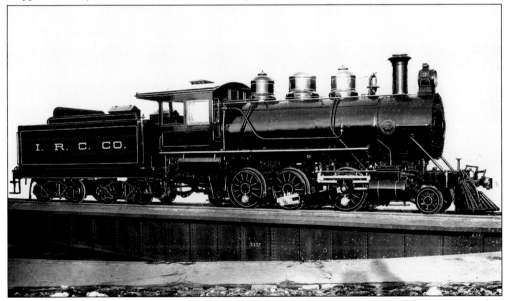

Baldwin built this hefty 2-6-0 Mogul for the Isle Royale Connecting Railroad that operated at the Isle Royale Mine on the hill above Houghton and not on the island of the same name. The Isle Royale Mine was located in an area called Hurontown and was the first mine to use the light portable compressed air drill developed by Rand Drill Company of New York at the urging of the mine's agent, John Mabbs. (George E. Anderson collection.)

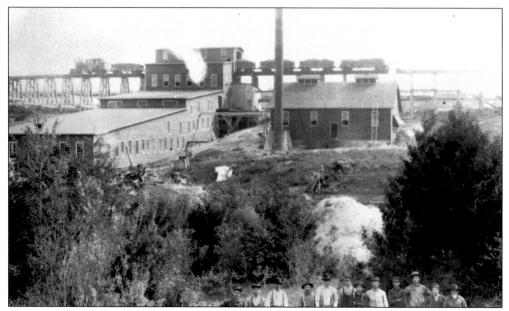

The 25-ton Climax engine pulling a string of rock cars through the Phoenix Mill was purchased new in October 1894 by the Traverse Bay and Copper Range Railroad of Hancock, Michigan, and later sold by the Keweenaw Central Railway in 1906. The line was three-foot narrow gauge, and when operations ceased, the cars were sold to the Quincy Mining Company for operation on the Quincy and Torch Lake Railroad. (MTU Archives and Copper Country Historical Collections, Michigan Technological University.)

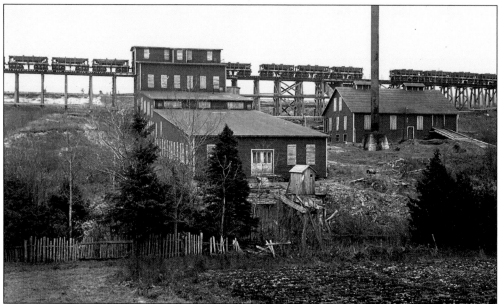

In this shot from another glass plate of the mill, over 16 cars are spotted on the loading trestle that runs above the rock bins in the stamp mill. Rock from these bins was fed to the stamp hammers below and then out to the wash tables. The Phoenix Mill was unique in that it was not located on a lake but drew its wash water from the nearby Eagle River. (MTU Archives and Copper Country Historical Collections, Michigan Technological University.)

Three

NARROW-GAUGE
COMMON CARRIERS

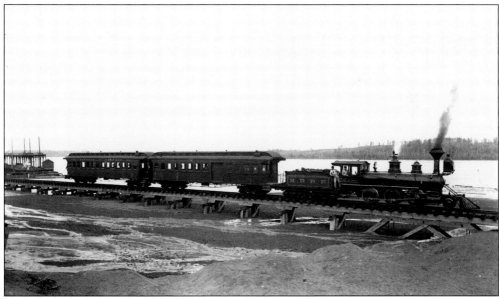

This scene would repeat itself for 16 years, from the start of operations in December 1885 up until standard gauging in November 1901. The short two-car train of these small Hancock and Calumet narrow-gauge coaches made three or four round trips daily along the shores of Torch Lake and Portage Lake between the towns of Lake Linden and Hancock, connecting at Hancock with Mineral Range Railroad trains to Calumet. (MTU Archives and Copper Country Historical Collections, Michigan Technological University.)

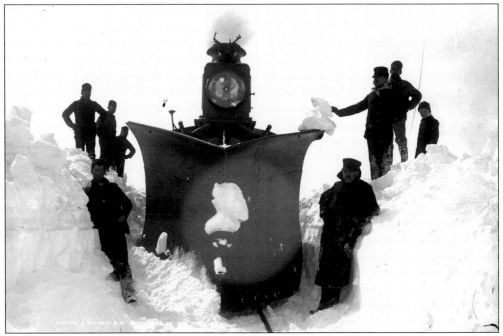

This little narrow-gauge Hancock and Calumet Railroad (H&C) locomotive is obscured by its huge pilot-mounted snowplow and dwarfed by its own enormous oil headlamp. The crew has adorned the headlamp with a set of deer antlers, and they are posed along the sides of the engine to emphasize the depth of the snowdrifts that the engine has been pushing its way through. (MTU Archives and Copper Country Historical Collections, Michigan Technological University.)

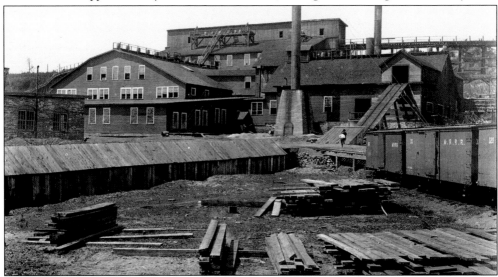

The first Osceola mill was served primarily by the Mineral Range Railroad, as evidenced by these boxcars, but the Osceola Mining Company agreed to supply its own rock cars and ordered the first 40 cars from Wells, French and Company of Chicago in 1874. This was the original mill on Portage Lake in Hancock, which was shut down in May 1885 and then taken apart and rebuilt on Torch Lake. (MTU Archives and Copper Country Historical Collections, Michigan Technological University.)

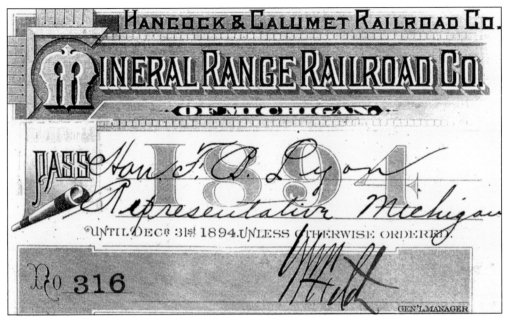

Although the H&C was built in 1885 by Joseph W. Clark and Albert S. Bigelow to compete directly with the Mineral Range in serving its own Tamarack and Osceola mines and mills, the H&C quickly came under the control of the Mineral Range and remained there for the rest of its 16-year existence. This pass from 1894 shows both names with the Mineral Range Railroad in large type. (George E. Anderson collection.)

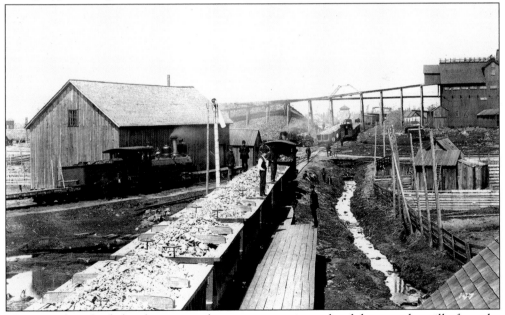

There are three loaded rock trains in this scene, preparing to head down to the mills, from the Osceola Mine. At their peak, the Tamarack Mine and Osceola Mine operated four mills and could process 28 trainloads of ore every day. The engine on the left with the empty flatcars has just dropped off a load of lumber products, cordwood, or prop timbers at the mine. (George E. Anderson collection.)

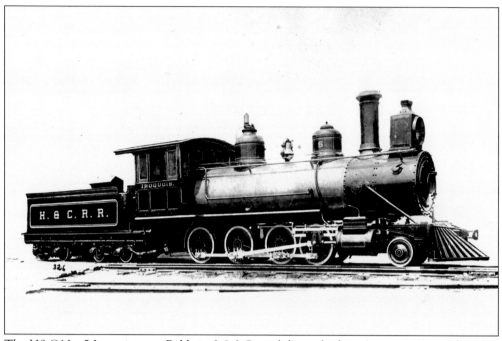

The H&C No. 5 *Iroquois* was a Baldwin 2-8-0 Consolidation built in August 1887 as C/N 8699. It was renumbered in October 1893 to H&C No. 32 and was sold in November 1902. Its sister engine, H&C No. 7 *Opeechee*, built in 1891, was renumbered in 1893 to H&C No. 34 and sold to the Quincy and Torch Lake Railroad (Q&TL) in November, 1901 and is now on display at the Quincy Mine. (George E. Anderson collection.)

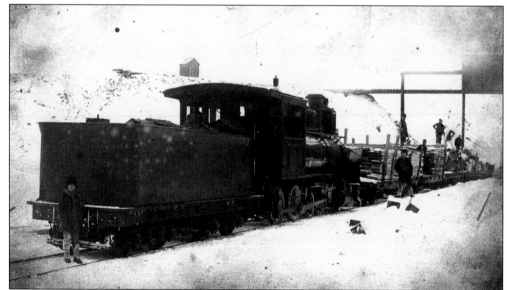

The H&C had six narrow-gauge Consolidations all built by Baldwin Locomotive Works between 1885 and 1891. This is probably No. 5, the *Iroquois*, equipped with a pilot plow pushing a mixed load of cut lumber and mine props into the Osceola mining area. Judging by the size of those timbers and the clouds of steam and smoke in the distance, there is undoubtedly another engine or two up ahead. (George E. Anderson collection.)

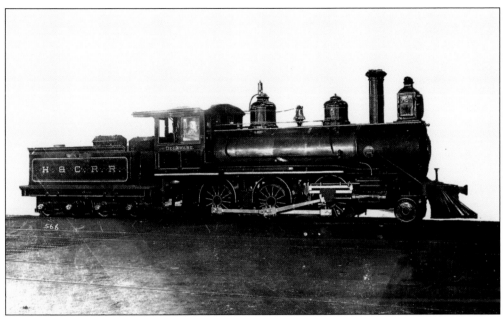

The H&C engine No. 8, the *Delaware*, was a 2-6-0 Mogul built by Baldwin as C/N 12335 in November 1891. When the Mineral Range Railroad standard gauged its line in 1897 this engine was apparently traded and sold by the Mineral Range. The H&C retained the former Mineral Range No. 8 *Red Jacket*, a Baldwin narrow-gauge Vauclain Compound 2-6-0 Mogul, which it then renumbered H&C No. 40. (George E. Anderson collection.)

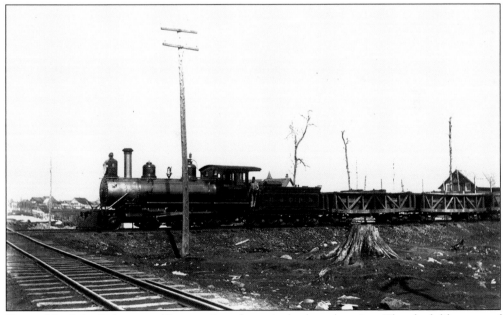

Here is No. 8 the *Delaware* pulling a string of empties back to the mine. They look like some of the original Wells, French and Company rock cars, some of them still lettered for the Osceola Mining Company rather than for the H&C like the later cars. They may not have been quite up to the heavy ore loads and seem to have developed a slight swayback look. (Houghton County Historical Society Archives.)

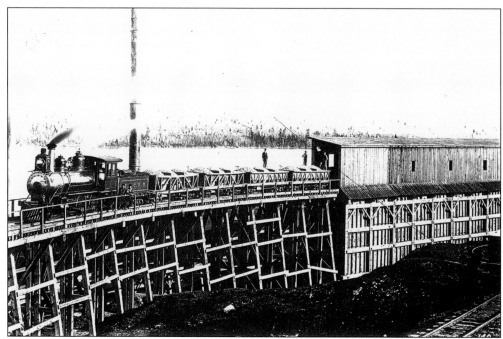

H&C engine No. 8, the *Delaware*, a Baldwin Locomotive Works Mogul, is pushing loaded rock cars into the new Osceola mill on Torch Lake. The first two rock cars behind the engine are the early cars from Wells, French and Company in Chicago, and they are sagging from the heavy load. The other two cars are from a later batch that was more substantially braced, and they are not sagging as much. (George E. Anderson collection.)

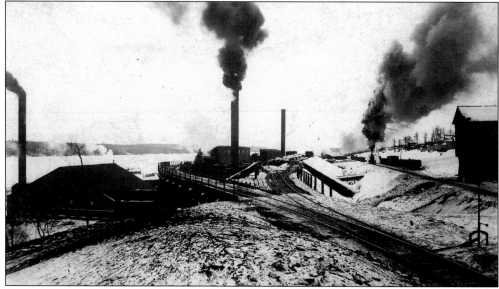

A busy day on the H&C rails down on Torch Lake. At the left stands the Osceola mill with the Tamarack mill beyond it in the center, and on the right is a water tower for the railroad, constructed like the water tower that still remains on Quincy Hill, with a riveted iron horizontal tank inside the structure and a stove beneath the tank to keep the water from freezing in the winter. (George E. Anderson collection.)

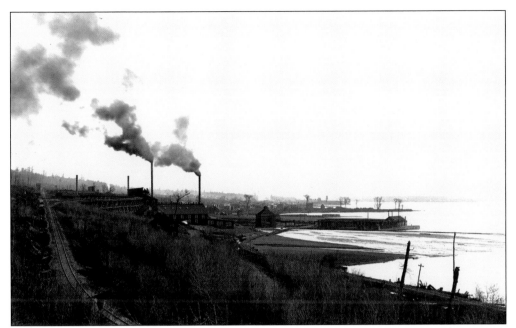

Looking north up the three-foot narrow-gauge H&C tracks toward the Osceola and Tamarack mills, the railroad water tower can be seen in the distance on the left with the stamp mills belching smoke in the center and the stamp sand running out into the lake on the right. The rails continue downhill from the left to junction with the Mineral Range Railroad tracks on Torch Lake. (MTU Archives and Copper Country Historical Collections, Michigan Technological University.)

An interesting shipment of stamp shoes is being delivered on these two small narrow-gauge Mineral Range Railroad flatcars to supply a mill somewhere along the line. As their ships entered the portage, early visitors to the area told of the loud and constant sound of the hammering of these shoes against the ore that emanated from the stamp mills that lined the lake. (MTU Archives and Copper Country Historical Collections, Michigan Technological University.)

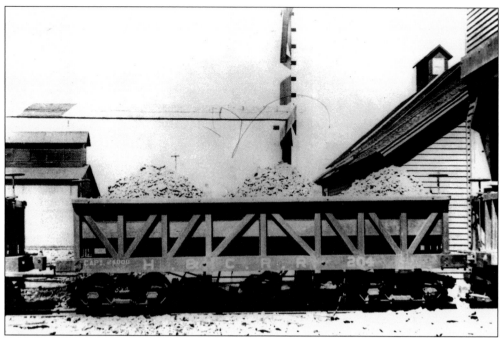

Car No. 204 is one of the H&C 200 series narrow-gauge Z-braced rock cars with a 24,000-pound capacity. These were 22-foot cars and of more sturdy construction that the earlier 20-foot cars. They were built in the late 1880s, and the construction appears to be almost identical to the first group of Q&TL Z-braced rock cars ordered from Chicago's Wells, French and Company in August 1889. (George E. Anderson collection.)

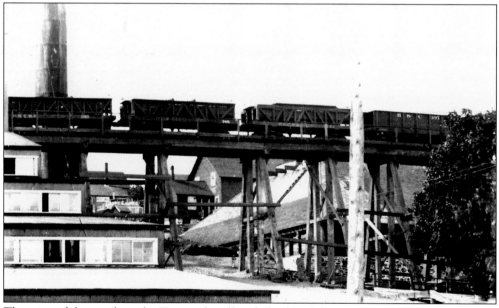

This view of the trestle at the Tamarack mill includes four different versions of H&C rock cars. The first car on the left is on of the 200 series Z-braced rock cars No. 290, while the next two cars appear to be different versions of the 300 series Z-braced rock cars, and the last car on the far right is a 300 series straight-braced rock car No. 397. (George E. Anderson collection.)

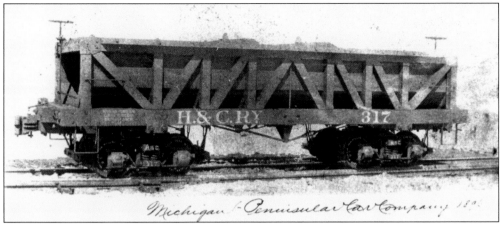

Michigan - Peninsular Car Company 189-

These 36-inch narrow-gauge H&C 300 series Z-braced rock cars were built in Detroit by the Michigan-Peninsular Car Company in 1896. They were used extensively to carry the copper bearing rock from the mines at Osceola, Tamarack, Tamarack Jr., and Kearsarge to the stamp mills down on Torch Lake. When the H&C was standard gauged in 1902, many of these cars were purchased by the Q&TL and used until the end of its operations in 1945. It is interesting to note that the little 22-foot-long narrow-gauge cars were equipped with modern knuckle couplers, while the standard gauge Duluth, South Shore and Atlantic Railway (DSS&A) flatcar that they rode upon still had link and pin couplers to haul them from the builder in Detroit up to the Copper Country. (George E. Anderson collection.)

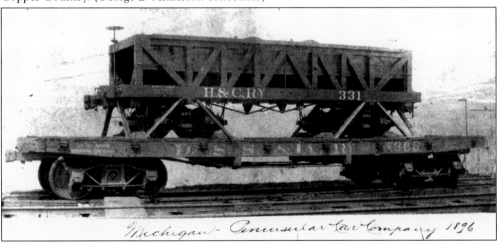

Michigan - Peninsular Car Company 1896

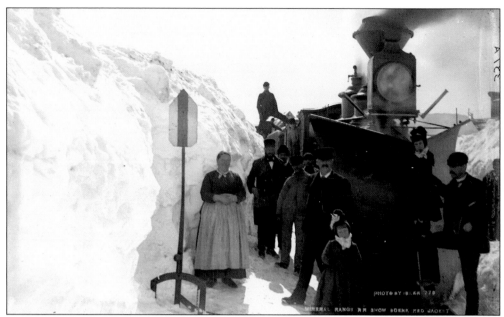

Judging by the double curve of the cab roof, which is just barely visible behind the huge pilot plow, this is probably Mineral Range Railroad No. 3, the *Keweenaw,* a Baldwin 2-6-0 Mogul built in June 1875, C/N 3741. The huge snowdrifts tower over the tiny engine, but the scene is most likely right in town because there are buildings in the background, several children, and the lady in the apron. (MTU Archives and Copper Country Historical Collections, Michigan Technological University.)

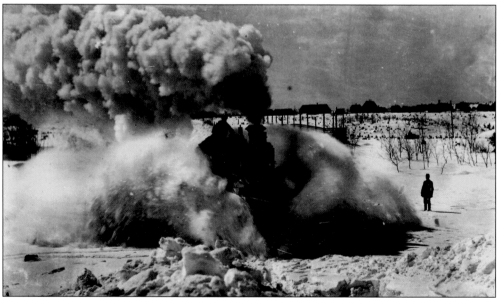

A typical winter day, March 28, 1893, finds an H&C engine running extra and bucking about two feet of snow with its pilot plow. This engine appears to be one of H&C's six Baldwin Consolidations, still sporting its handsome Victorian capped stack and huge oil headlamp. Note the spotter clinging precariously to the cab roof, certainly not one of the most desirable jobs on the railroad. (George E. Anderson collection.)

In this pair of Adolph F. Isler photographs, a load of cordwood is seen snaking its way through the forest behind a little three-foot gauge H&C locomotive. The very intrepid photographer has captured this long load of cordwood, bound for the Bollman Lumber Company, at a location in the woods between Mohawk and Gay. The engine H&C No. 8, the *Delaware*, was a Baldwin 2-6-0 Mogul built in November 1891. It still looks fresh and new in this view from the early 1890s. The first picture was found in Michigan and the second was found in Arizona (the other copper country), with identical Isler imprints on the back. They are reunited here on this page for the first time in over 100 years. (George E. Anderson collection.)

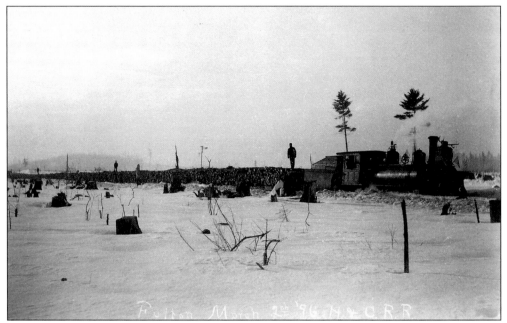

Another load of cordwood is seen at Fulton, the northern terminus of the H&C. From the time the railroad reached Fulton in 1891, until this picture was taken on March 2, 1896, extensive cutting of cordwood and mine props had been done, as witnessed by the stumps poking through the snow. Lumber products made up about 20 percent of the tonnage that was carried annually by the railroad. (George E. Anderson collection.)

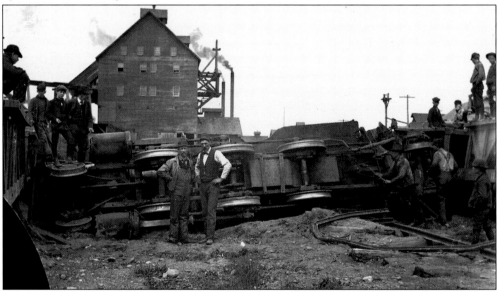

This photograph, dated January 1901, bears witness to what was probably the last run of H&C engine No. 1, the *Torch Lake*, a Brooks Mogul C/N 834, built in December 1882 for the Toledo, Cincinnati and St. Louis (TC&StL) and purchased by H&C in July 1885. At this time, it would have been carrying the No. 25 from the October 1893 renumbering and was sold in December 1901, most likely for its scrap value. (MTU Archives and Copper Country Historical Collections, Michigan Technological University.)

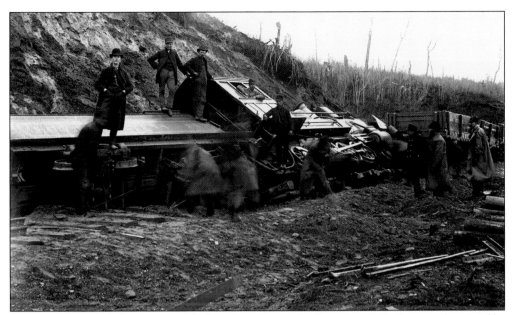

This wreck on the H&C occurred during the spring melt when the roadbed was undermined by severe runoff. The errant locomotive appears to be the No. 7 *Opeechee*, a Baldwin 2-8-0 built in January 1891, C/N 11534, which was renumbered H&C No. 34 in October 1893 and finally became the Q&TL No. 5 in November 1901. (MTU Archives and Copper Country Historical Collections, Michigan Technological University.)

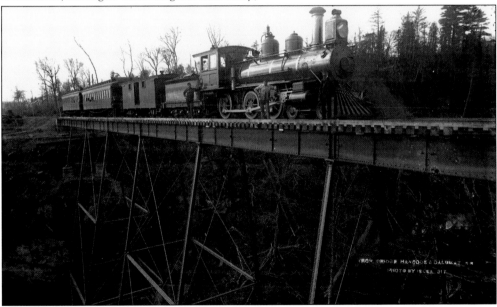

The H&C's only 4-6-0, engine No. 4 *Kearsarge*, a 10-wheeler built by Baldwin C/N 8044 in July 1886, pulls a passenger train from Upper Mills headed for Calumet over the high iron trestle at Hungarian Creek. This portion of the H&C passenger operation lasted only about three years and had ceased by 1890, although the product of the mining operations had increased considerably coming down to the mills. (MTU Archives and Copper Country Historical Collections, Michigan Technological University.)

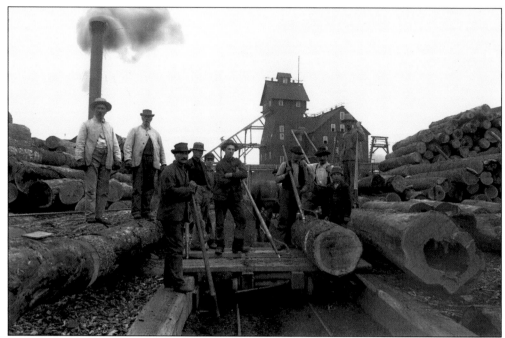

The surface crew at Tamarack No. 2, armed with picks and peaveys, the tools of their trade, is selecting mine props from the timber yard and loading them onto a platform car for delivery to the shaft house behind them. The load of huge timbers will be taken underground to prop up the extensive network of tunnels and shafts to prevent them from collapsing. (MTU Archives and Copper Country Historical Collections, Michigan Technological University.)

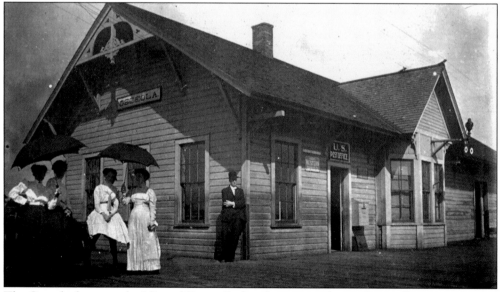

The Osceola depot on the Mineral Range Railroad appears to have a bevy of beauties awaiting the train this sunny day. The bay window area was occupied by the agent and or telegrapher whose reports controlled train movement along the line. This agent also was responsible for Western Union and Railway Express (the UPS of the rail age) duties. (MTU Archives and Copper Country Historical Collections, Michigan Technological University.)

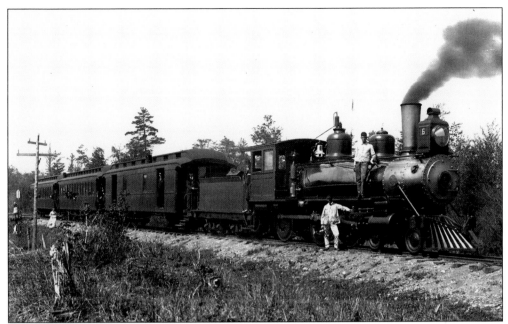

In this image, Mineral Range 4-6-0 No. 6 heads north toward Calumet with a local passenger train around 1880. The train consist includes a baggage and two open platform coaches. This photograph was likely taken on the long straight mainline between Hancock and Calumet around the Boston Township location. The conductors peer out from the baggage car. (MTU Archives and Copper Country Historical Collections, Michigan Technological University.)

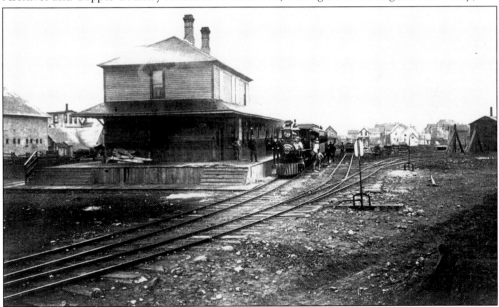

Here Mineral Range No. 1, the *Jay A. Hubbell*, and its passenger train have arrived at the platform of the Red Jacket depot. The engine house and turntable are visible on the extreme right side of this R. Acton photograph. The second floor of this combined freight and passenger station allowed the agent and his family to live right where he worked. (Houghton County Historical Society Archives.)

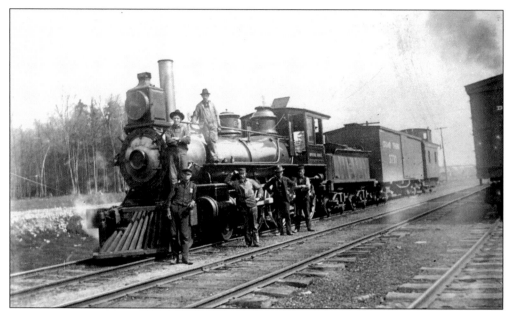

This early standard-gauge Mineral Range Railroad locomotive was a hand-me-down from the parent DSS&A with its huge oil headlamp and fluted domes. It is seen here in the yards at Calumet with a Grand Trunk boxcar and a small four-wheel bobber in tow. Surely this used equipment made the Mineral Range anxious to upgrade to newer more modern standard-gauge equipment. (Houghton County Historical Society Archives.)

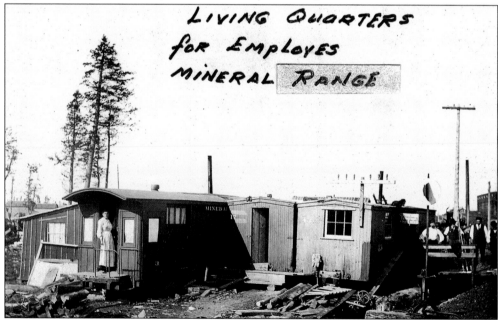

A variety of used equipment is seen here assembled into a station and living quarters for Mineral Range employees working on the 1899 "South Range Extension" running west from Keweenaw Bay to Peppard. On the left is the smoking and baggage car No. 3 delivered from the Jackson and Sharp Company in June 1874, in the center is diminutive box car No. 17 from about 1886, and on the right is 1892 box car No. 43. (George E. Anderson collection.)

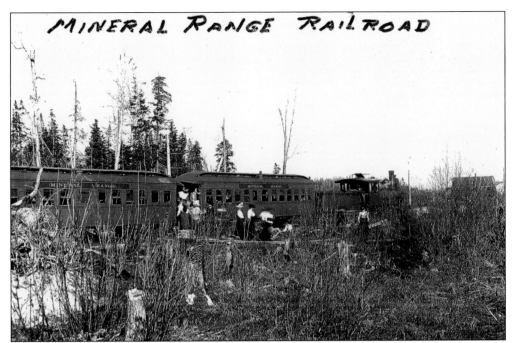

Seen here is a passenger excursion pausing on the newly completed South Range Division. Up front is engine No. 202, an ex-DSS&A 2-6-0 Mogul built by Baldwin Locomotive Works in 1884 for the Marquette and Western Railroad (M&W). Behind the engine are two of the early-1870s coaches. The first is the 1873 *Calumet* and on the left is No. 2 *Osceola* of 1874. Both were previously narrow-gauge coaches with standard-gauge trucks placed under them by parent DSS&A. (George E. Anderson collection.)

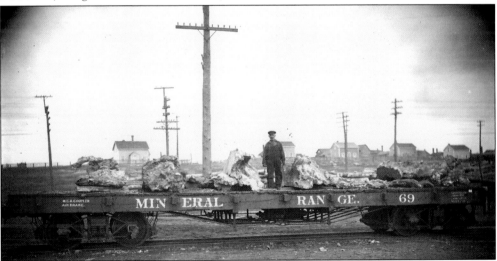

The man standing on the Mineral Range flatcar No. 69 gives a sense of scale to the huge chunks of mass copper surrounding him. With several Quincy Mining Company houses in the background and a note on the original negative sleeve reading "mass copper at Quincy No. 2" leads the authors to believe that this picture was taken on the Mineral Range trackage at the Quincy No. 2 shaft location. (MTU Archives and Copper Country Historical Collections, Michigan Technological University.)

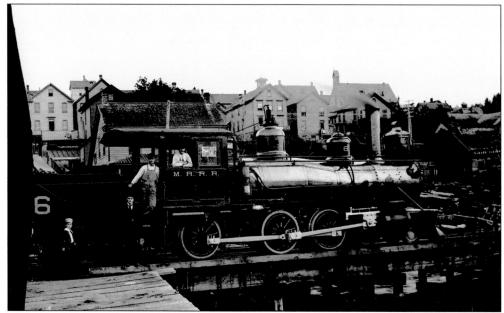

Mineral Range Railroad 4-6-0 Mogul No. 6 sits "on the docks" at Hancock. Founded to serve the mines on the Keweenaw, the Mineral Range was built to three-foot gauge and was intended to haul freight from these docks on Portage Canal to mine sites in the interior of the peninsula. Once standard-gauge railroads made their appearance in the Copper Country, the Mineral Range (absorbed by the DSS&A) standard gauged its tracks. (MTU Archives and Copper Country Historical Collections, Michigan Technological University.)

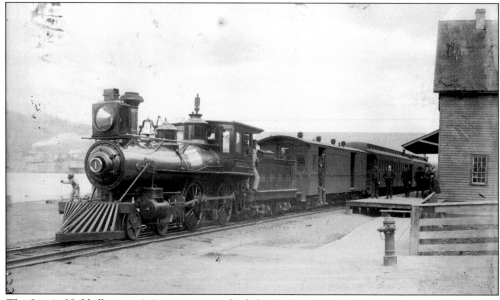

The *Jay A. Hubbell*, a 4-4-0 American, was built by H. K. Porter Company probably as C/N 440 in July 1881 as a 2-4-0 and bought used in 1886. It became the second No. 1 on the Mineral Range. In this scene at the Houghton depot, the engine is followed by an early smoking and baggage car, an H&C coach, and a Mineral Range coach. (MTU Archives and Copper Country Historical Collections, Michigan Technological University.)

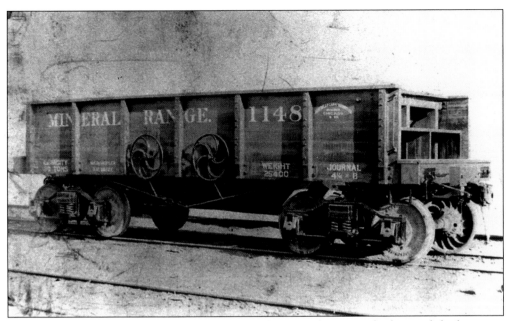

Some of the first rock cars ordered by the Mineral Range after it standard gauged the line were these small 30-ton cars. The Mineral Range ordered a batch of 100 cars from American Car and Foundry in Chicago on May 8, 1902. These cars were a step up from the earlier narrow-gauge rock cars, but they were quickly supplanted by the larger 40-ton cars ordered in subsequent years starting in 1903. (George E. Anderson collection.)

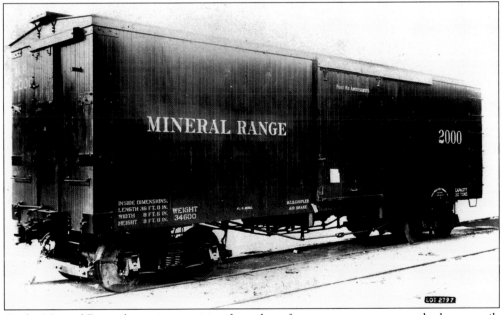

As the Mineral Range began its transition from three-foot narrow-gauge to standard-gauge rails in the 1898–1899 period, it would be kept busy the next few years building up its freight car fleet. These 36-foot-long boxcars were ordered from American Car and Foundry in Chicago on March 14, 1903. There were 50 boxcars in lot No. 2797 with a capacity of 30 tons and weight of 34,600 pounds. (George E. Anderson collection.)

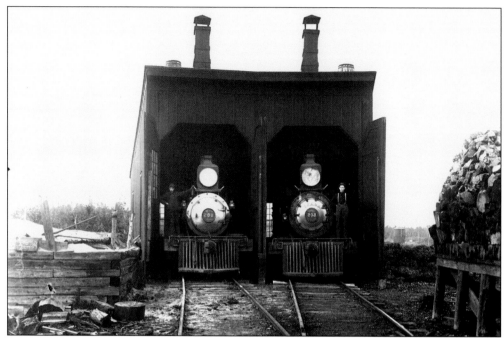

As the Mineral Range Railroad converted to standard gauge, it settled for old engines from the DSS&A as seen here on the South Range Division. On the left is engine No. 208, the former Marquette, Houghton and Ontonagon Railroad (MH&O) *Kabibonokka* and DSS&A No. 36, a 2-6-0 Mogul built by Hinkley Locomotive Works in 1883. On the right is engine No. 202, former M&W No. 52, a 2-6-0 Mogul built by Baldwin in 1884 and rebuilt by DSS&A in 1890. (MTU Archives and Copper Country Historical Collections, Michigan Technological University.)

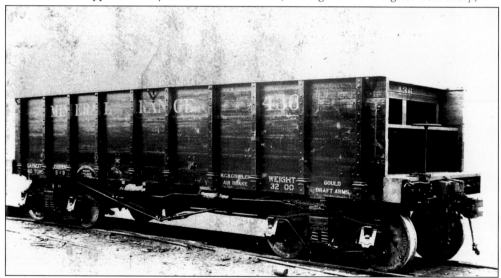

This Mineral Range wood hopper, car No. 436, was one of the early groups of standard-gauge 40-ton rock cars built by American Car and Foundry in Chicago. The railroad ordered 100 of these 32,000-pound-capacity cars on March 14, 1903. As was typical of these center dump wooden hoppers, the brake cylinders were mounted under the side rail to keep them clear of the dump doors. (George E. Anderson collection.)

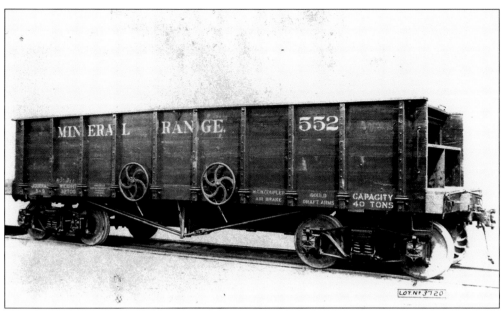

Wooden hopper car No. 552 was one of the Mineral Range's middle groups of 40-ton rock cars built by American Car and Foundry in Chicago. There were 50 of these 32,000-pound-capacity cars ordered by the railroad in 1905. This view of the car in the builders photograph shows the control wheels for the dump mechanism, while the brake gear was mounted on the opposite side of the car. (George E. Anderson collection.)

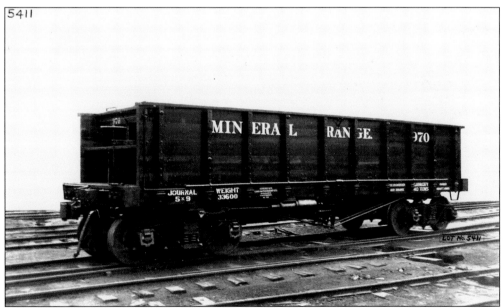

This wooden hopper car is from one of the later groups of 40-ton rock cars built for the Mineral Range by American Car and Foundry in Chicago. This order for 50 cars of 33,600-pound capacity was placed on January 12, 1908. The photograph shows a unitized brake cylinder rather than the split system in evidence on the earlier cars. (George E. Anderson collection.)

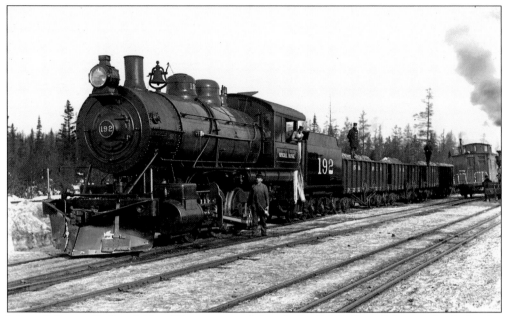

Mineral Range Railroad No. 192 was one of four hefty 2-8-0 Consolidations built for the railroad by Rogers Locomotive and Machine Works in 1902, C/N 5599. It sits simmering in the dual-gauge yards in Calumet with a loaded train of the new 40-ton rock cars from American Car and Foundry. The ore was on its way from the Tamarack Mine and Osceola Mine down to the mills on the lake. (MTU Archives and Copper Country Historical Collections, Michigan Technological University.)

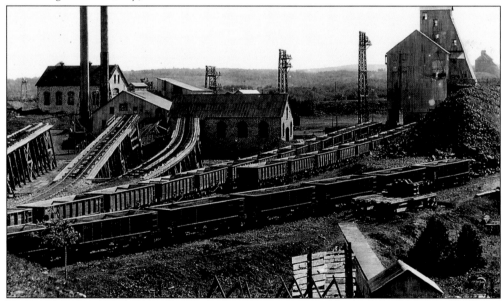

This 1913 view at the Kearsarge Mine north of Calumet gives a look at 35 of the standard gauge Mineral Range 40-ton wooden rock cars built by American Car and Foundry in Chicago during the early 1900s. For about 10 years, from 1903 to 1913, the Mineral Range continued to order these 40-ton cars to keep its fleet in line with the production of the mines and the capacity of the mills. (George E. Anderson collection.)

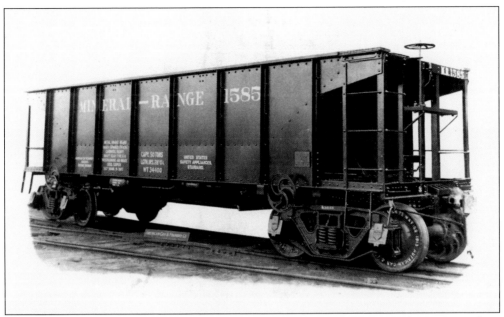

As the car builders moved to steel construction, the Mineral Range took notice, and on March 17, 1913, the railroad ordered 100 steel hopper cars from American Car and Foundry in Detroit. Mineral Range steel hopper car No. 1585 was completed on May 22, 1913. It weighted 34,400 pounds and had an inside length of 28 feet and a 50-ton capacity. The new steel cars served so well that the railroad ordered another 100 cars from American Car and Foundry on January 14, 1916. This second group, including No. 1698, was built at the American Car and Foundry facility in St. Louis and weighed slightly more at 34,600 pounds but had the same length and capacity. These cars were eventually relettered for the parent DSS&A, and all 200 cars are shown on the January 9, 1926, equipment roster. The DSS&A revised the roster on February 1, 1930, and showed only 40 cars remaining. (George E. Anderson collection.)

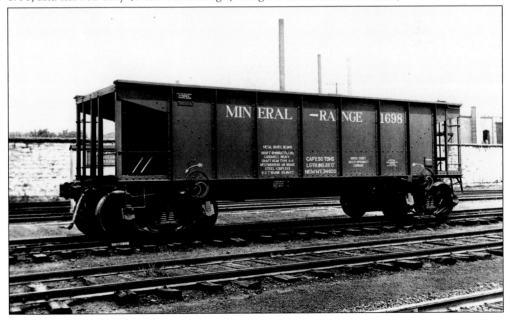

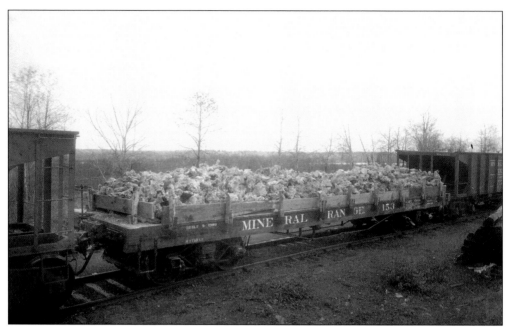

A standard gauge Mineral Range Railroad flatcar No. 153 fitted with low sideboards is filled to overflowing with large chunks of mass copper brought up to the surface from the Isle Royale Mine. The Isle Royale Mine was located not on Isle Royale, but rather was south of Portage Lake at the top of the hill above the city of Houghton. (MTU Archives and Copper Country Historical Collections, Michigan Technological University.)

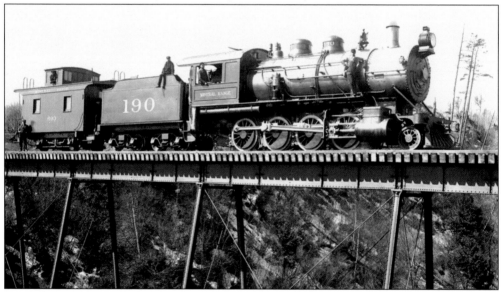

Mineral Range engine No. 190 was one of four standard-gauge 2-8-0 Consolidations that the railroad purchased in 1902 from Rogers, C/N 5697. It is seen here with a tiny four-wheel bobber caboose in tow while the train is crossing the tall steel Hungarian Falls trestle that spans the Hungarian Creek ravine. Meanwhile the brave crew tries to strike casual poses for the photographer. (MTU Archives and Copper Country Historical Collections, Michigan Technological University.)

Four

MAJOR
STANDARD-GAUGE LINES

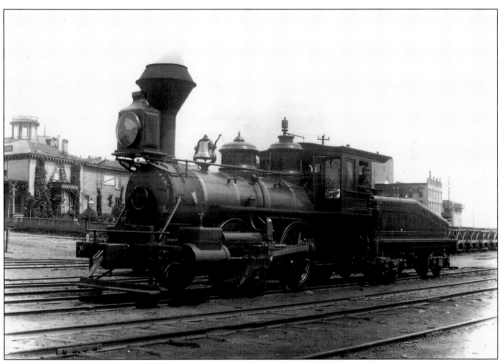

The ancient MH&O engine No. 40 *Neebanawaigs* is seen here in its factory paint, and still sporting its distinctive double curved cab roof. The engine was built by the Hinkley Locomotive Works in 1883 and became DSS&A No. 40 when the MH&O was bought out by the DSS&A in 1890. It was later renumbered to No. 10 by the DSS&A and was gone from the roster by 1926. (George E. Anderson collection.)

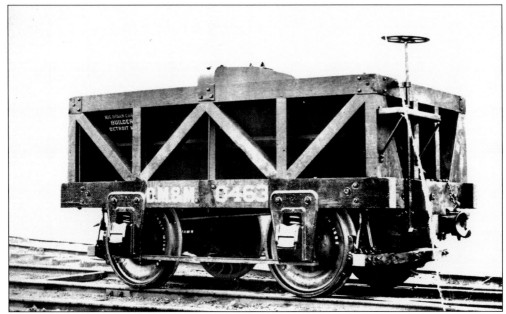

This little Detroit, Mackinac and Marquette Railroad (DM&M) four-wheel ore car No. 0463 was built by the Michigan Car Company in Detroit in 1882. The cost of each car was $280, and by 1885, the DM&M had 800 of these cars on the roster. The railroad, however, was a continual money loser and was put up for auction on October 20, 1886, but the DM&M Land Company remained in existence until May 2, 1958. (George E. Anderson collection.)

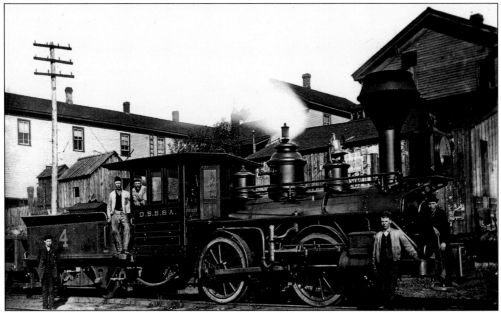

Built for the Cleveland Iron Mining Company as its *Cleveland* by Taunton Locomotive Works in 1873 as C/N 598, DSS&A 0-4-0 No. 4 was the first engine to run on the completed line from Champion to L'Anse as MH&O No. 17, named the *Keweenaw*. This locomotive was identical to DSS&A No. 3, also built by Taunton 1873, and worked the docks until 1926 when it was finally scrapped or sold. (George E. Anderson collection.)

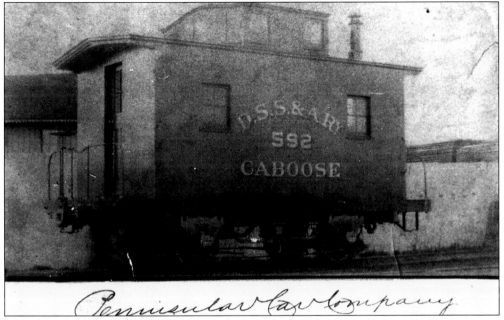

Peninsular Car Company

This charming little four-wheel bobber was built for the DSS&A by the Peninsular Car Company at some time between 1884 and 1892. The distinctive feature that made it so unique was the double ogee curved roof on the cupola. A sweeping curve was also applied to the DSS&A lettering and the need to spell out the word *caboose* soon went out of fashion. (George E. Anderson collection.)

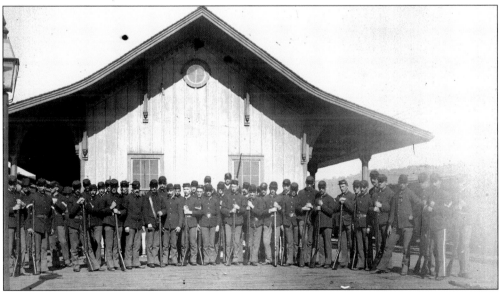

A large company of militia assembles for an informal picture on the east end of the old DSS&A depot in Houghton around 1880. Note that they still wear the Civil War keppi-style slouch infantry caps that were in use until the 1880s. The distinctive Victorian architecture features vertical board-and-batten siding, dental mouldings under the eaves, and ornately carved supports for the overhanging roof. (MTU Archives and Copper Country Historical Collections, Michigan Technological University.)

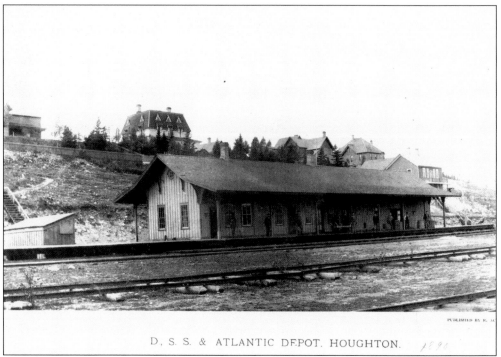

D. S. S. & ATLANTIC DEPOT. HOUGHTON.

The first MH&O depot in Houghton was a wood frame structure. It was originally owned by the Mineral Range Railroad, but when the MH&O was bought out by the DSS&A, the Mineral Range and the DSS&A shared the depot. It was replaced by the current Jacobsville sandstone structure around 1900. (MTU Archives and Copper Country Historical Collections, Michigan Technological University.)

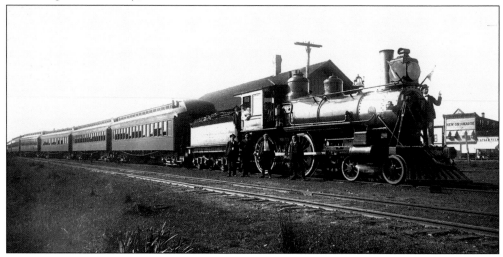

Around 1890, DSS&A engine No. 104, Baldwin C/N 9398, a 4-4-0 built in 1888, stands beside the Ontonagon depot. The white flags indicate that it is "running extra," and the photographer standing on the pilot deck of the engine with his tripod and camera lead one to suspect that all of the passengers on this special run are gathered in front of the locomotive for a group picture to commemorate the occasion. (MTU Archives and Copper Country Historical Collections, Michigan Technological University.)

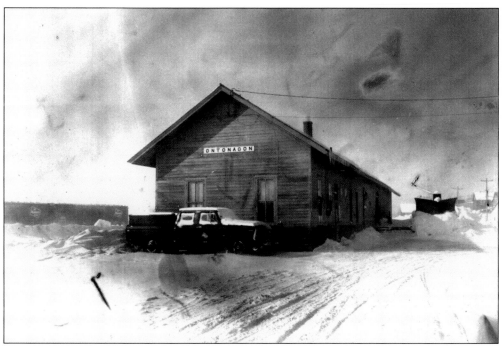

It is a cold and blustery winter day at the Ontonagon train depot. The crew has not moved the pickup truck since the last several inches of snow has fallen, but the wind is trying to clear the windows. On the right an engine labors shoving a snowplow to clear the rails past the station. (MTU Archives and Copper Country Historical Collections, Michigan Technological University.)

DULUTH SOUTH SHORE & ATLANTIC RY. CO.
MINERAL RANGE R. R. CO.

1913

No. G 1508

PASS Mrs. E.G.Clark and son,
 Family of A. G. F. A.,
ACCOUNT M. St.P. & S.S.M. Ry.

OVER ENTIRE SYSTEM
UNTIL DECEMBER 31ST UNLESS OTHERWISE ORDERED AND
SUBJECT TO CONDITIONS ON BACK

VICE PRESIDENT & GENERAL MANAGER.

On October 1, 1893, the DSS&A took possession of the Mineral Range, and looking at this pass from 1913, shows that the close relationship continued between the DSS&A and the Mineral Range. Both railroad names appear in the same size type, but the Mineral Range is listed second and the DSS&A gets top billing, befitting its ownership status. (George E. Anderson collection.)

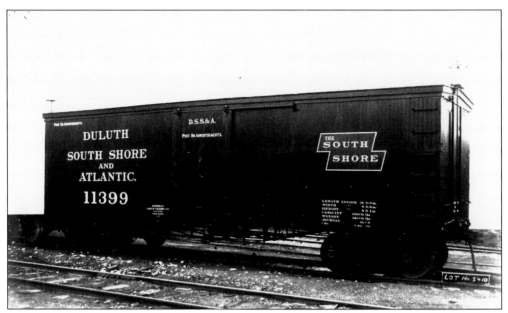

The close relationship between the Mineral Range Railroad and the DSS&A is further attested to by this group of 40 boxcars, ordered by the Mineral Range on January 12, 1908, from American Car and Foundry in Chicago. The 36-foot boxcars in lot No. 5410 were completed on April 26, 1909, and as seen here were lettered for the DSS&A. (George E. Anderson collection.)

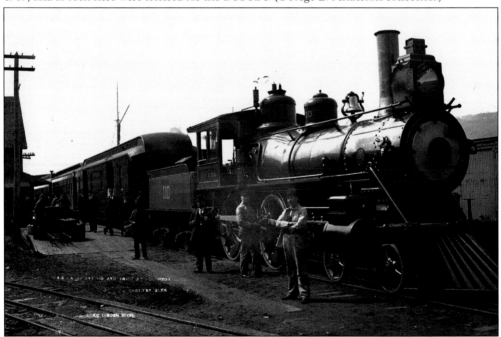

The high-stepping passenger engine No. 110, C/N 9432, seen in this Adolph F. Isler photograph, was one of the 15 Baldwin 4-4-0 American locomotives delivered to the DSS&A in 1888. The Mineral Range would drop off passengers here at the Houghton depot, and they would then board the DSS&A train that was bound for Marquette and other eastern destinations. (MTU Archives and Copper Country Historical Collections, Michigan Technological University.)

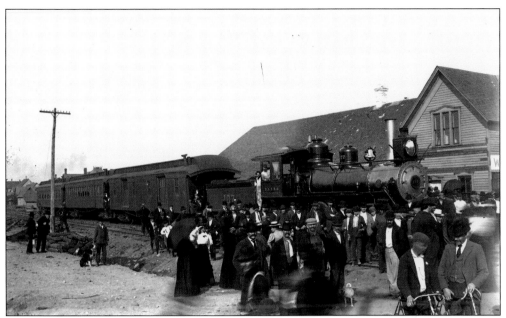

Engine No. 107, another Baldwin 4-4-0, C/N 9402, was one of the batch of 15 delivered in 1888. A large group of people is crowded around the engine that has just arrived at the Calumet depot, which is displaying a welcome banner to the passengers. The train is typical, consisting of a baggage car and two coaches. (MTU Archives and Copper Country Historical Collections, Michigan Technological University.)

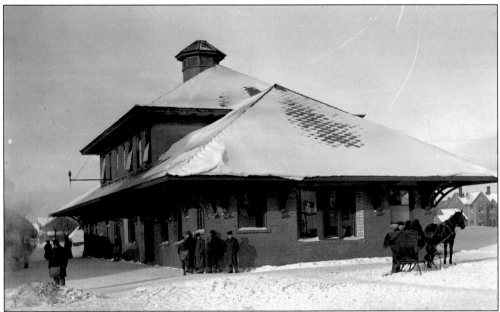

A horse and cutter are pulled up at the Calumet Union Station in the early 1900s. Horsepower was still the best way to get around in the winter in the Keweenaw until the 1920s, when advances in automobile tires and technology made cars more reliable in the winter. This photograph is dated 1914. (MTU Archives and Copper Country Historical Collections, Michigan Technological University.)

The two railroads would continue their close bond until well after World War II, as can be seen here from this pass issued as late as 1949 for the jointly owned railroads. Although the Mineral Range Railroad name would disappear from subsequent DSS&A passes, the actual rail line itself would continue to be operated until final abandonment by the Soo Line Railroad management in 1978. (George E. Anderson collection.)

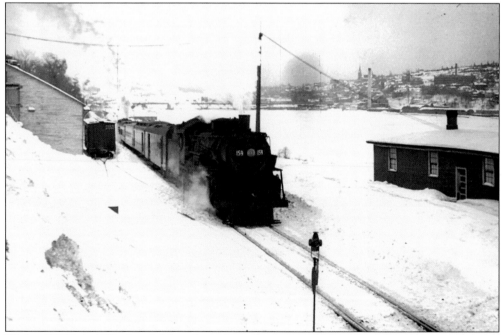

With a DSS&A 1050-class 2-8-2 pushing from the rear, Milwaukee Road Pacific No. 159, with its 80-inch drivers struggles up the 4 percent grade of Hancock Hill around 1950. A potato warehouse is at the left, and the Armstrong Thielman Lumber Company Planing Mill is on the right. Milwaukee Road 4-6-2 engine No. 159 had brought the Copper County Limited through from Champion. (Rudolph Maki collection.)

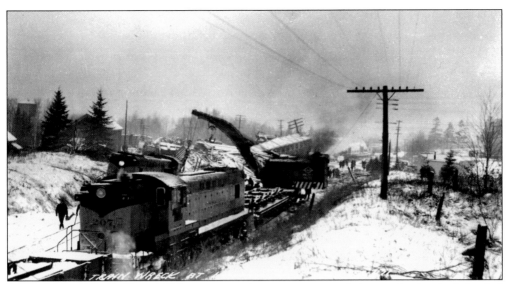

DSS&A No. 207 a Baldwin E616 spots a wrecking crane to rerail sister units that had derailed near L'Anse in March 1971. The entire train appears to have gone far off the frozen tracks and buried itself deep in the embankments. It will take quite an effort in this frigid weather to get everything cleaned up and under way again. (MTU Archives and Copper Country Historical Collections, Michigan Technological University.)

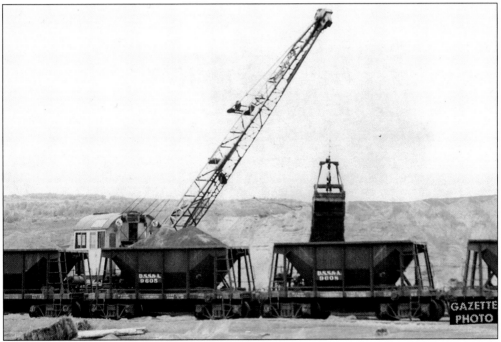

In the mid- to late 1950s, the DSS&A could be observed loading stamp sand from the Isle Royale mill on Portage Lake for use as ballast along its routes through the Copper Country. The rail crane with its claw bucket travels on a parallel spur track and loads the stamp sand into the waiting string of DSS&A iron ore dump cars. (MTU Archives and Copper Country Historical Collections, Michigan Technological University.)

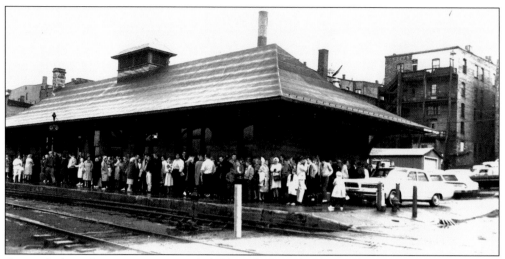

A crowd of people, men, women, and children, hide under the overhang and await the arrival of the next train at the DSS&A depot in Houghton about 1960. The crowds, the trains, and the tracks are long gone, but the building has been restored and now houses the offices of the Mattila Construction Company. (MTU Archives and Copper Country Historical Collections, Michigan Technological University.)

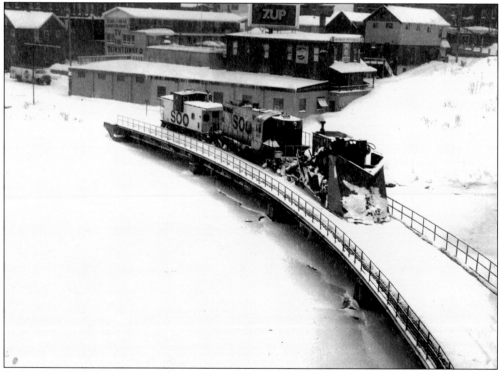

A Soo Line Railroad engine with a caboose in tow pushes a plow-flanger out onto the approach to the Houghton-Hancock lift bridge heading north from Houghton to clear the tracks up to Calumet. In the background, the 7-UP Bottling Company and the Downtowner Motel in Houghton can be seen. (MTU Archives and Copper Country Historical Collections, Michigan Technological University.)

Five

Narrow Gauge on the Hill

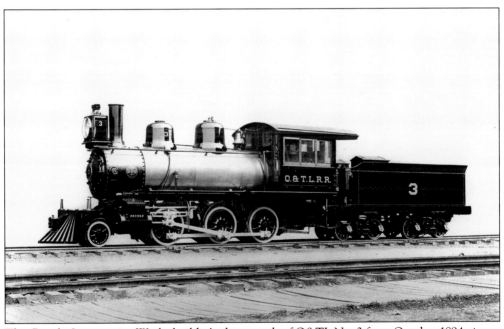

This Brooks Locomotive Works builder's photograph of Q&TL No. 3 from October 1894 gives a good look at some of the unique features that Brooks applied to these engines. In addition to the canted valve chest on top of the cylinders, there were no boiler braces down to the pilot deck, and the stack is not centered over the cylinders, which was the normal practice among most engine builders. (George E. Anderson collection.)

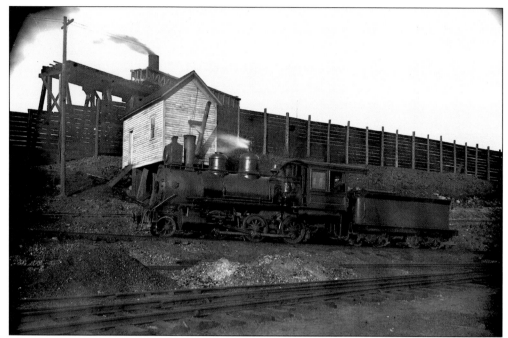

The Q&TL engine No. 1, the *Thomas F. Mason*, is seen here passing in front of the distinctive enclosed water tower that still stands on Quincy Hill. The water tower still wears its white clapboard siding in this early photograph, and it houses a horizontal water tank over the top of a stove that kept the water from freezing in the winter. (MTU Archives and Copper Country Historical Collections, Michigan Technological University.)

Here Q&TL caboose No. 04 is seen in front, being pushed by engine No. 1 with caboose No. 1 in tow behind the engine, all perched high on the steel trestle that led to the mills on Torch Lake. The wooden trestles that were put up in 1888 were replaced with steel structures 10 years later in 1898. Caboose No. 04 appears to be dark with white lettering at this time. (George E. Anderson collection.)

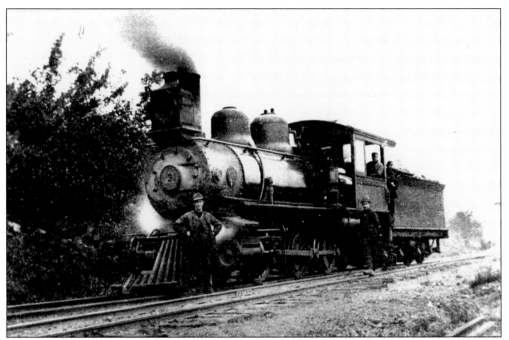

Q&TL engine No. 3 poses with its crew while working somewhere on the line. Purchased in 1894 from Brooks Locomotive Works, it was larger than the two previous engines supplied at the start of operations by the same builder, weighing in at 45 tons. It remained in service until the end of operations in 1945 and is now at the Huckleberry Railroad and Crossroads Village in Flint. (George E. Anderson collection.)

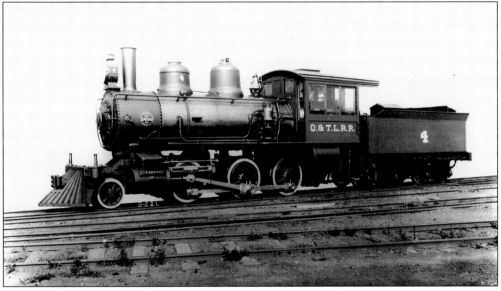

While the Q&TL No. 4 was almost identical to the 45-ton Mogul No. 3, it was not built until six years later in October 1900 and incorporated many mechanical and safety improvements. There was still quite a bit of trouble with No. 4, however, as some of the welds on the frame kept giving out. Brooks refused to accept responsibility for the failures claiming that Q&TL had overworked the engine. (George E. Anderson collection.)

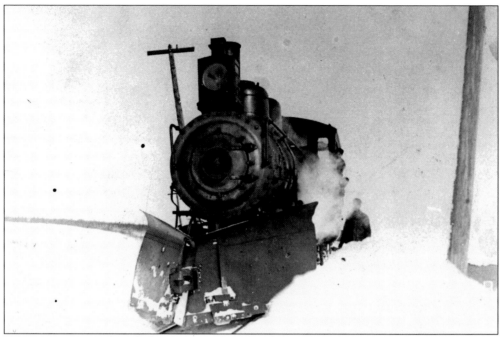

Q&TL No. 4 is seen here hiding behind a big pilot plow as the crew works to keep the road open for movement of rock cars from the mine to the mill. The engine, at 45 tons, was the same size as Q&TL No. 3 and was built by Brooks Locomotive Works in October 1900. It served the railroad until the end of operations in the 1940s, when it was scrapped. (George E. Anderson collection.)

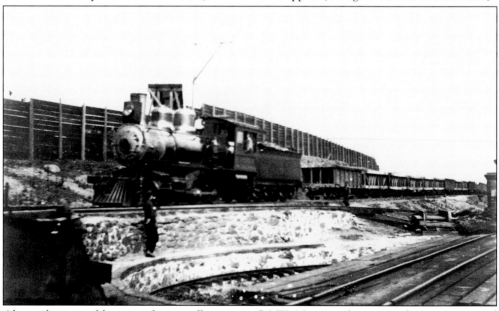

Above the turntable pit at the roundhouse sits Q&TL No. 4 with its very distinctive canted valve chest atop the cylinders and a string of mixed rock cars with straight braced and Z-braced cars. The 50-foot iron turntable was supplied by the Detroit Bridge Company in 1889 along with an identical one installed down at the mill. Both were replaced by wyes in 1912 to make snow removal easier. (George E. Anderson collection.)

Q&TL shaft house No. 2 looms large over the string of rock cars that are passing under its storage bin to be loaded with rock that is bound for the mills down on Torch Lake. The photographer is standing down in the old kiln that was used at one time to heat the rock and break it away from the pure metallic copper that was locked in its matrix. (MTU Archives and Copper Country Historical Collections, Michigan Technological University.)

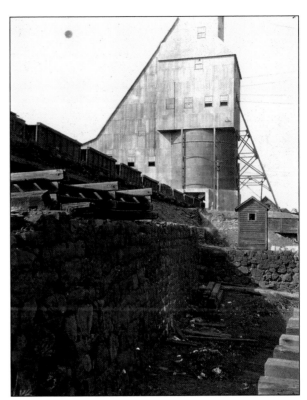

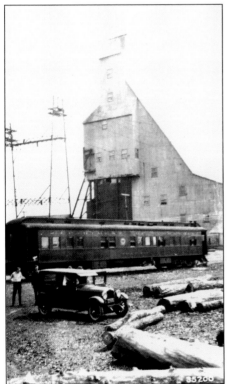

The Mineral Range Railroad served the Quincy mine properties on Quincy Hill and was the mine's standard gauge connection to the outside world. This photograph is believed to be from 1929, when the U.S. Bureau of Mines sent its private car to the property to investigate a fire in the famous No. 2 shaft seen in the background. Note the huge hemlock stopping timbers in the foreground. (MTU Archives and Copper Country Historical Collections, Michigan Technological University.)

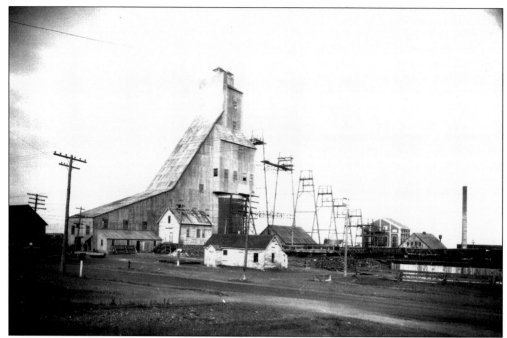

A string of Q&TL rock cars is entering the Quincy No. 2 shaft house to be loaded with rock that will be taken down to the mill for processing. Still visible on the roof of the shaft house is the guard shack that was installed to protect the property during the miners strike in 1913–1914. (MTU Archives and Copper Country Historical Collections, Michigan Technological University.)

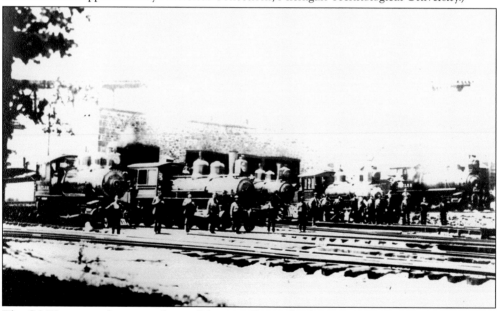

The Q&TL engines line up in front of the roundhouse for their portrait prior to the addition of engine No. 6 to the roster in early 1913. Q&TL No. 6 would be the largest and most powerful of the Quincy locomotives and was an outside frame 2-8-0 Consolidation built by Baldwin Locomotive Works in December 1912. It could haul as many as 44 empty rock cars back up to the mine. (George E. Anderson collection.)

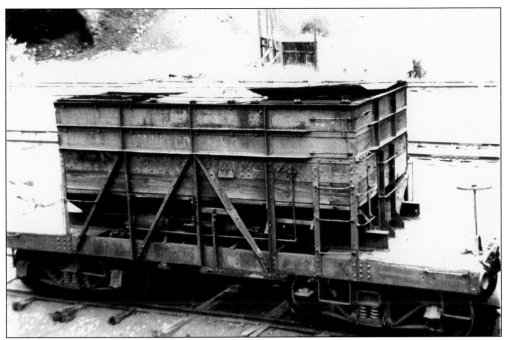

The Quincy Mining Company ordered four of these standard-gauge 60,000-pound-capacity concentrate cars in 1904 from the Pressed Steel Car Company of Chicago. The DSS&A, which controlled both the Mineral Range Railroad and H&C, was initially reluctant to accommodate the Quincy Mining Company's request to transport the mineral from the mill at Mason on Torch Lake to the smelter at Ripley on Portage Lake but finally agreed to build the spur if the Quincy Mining Company would supply the cars. These cars were therefore lettered for the Quincy Mining Company and were only operated over the standard-gauge Mineral Range trackage and were not part of the 36-inch narrow-gauge Q&TL. (George E. Anderson collection.)

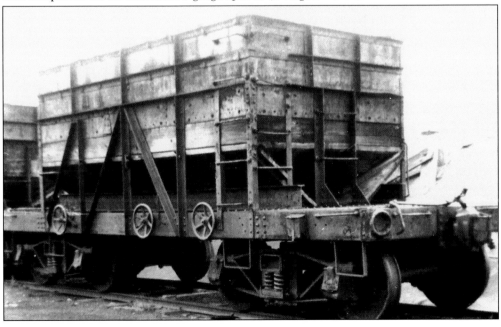

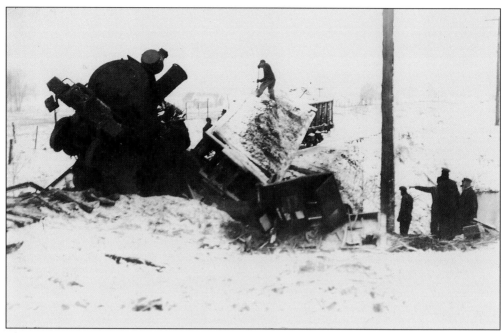

The only fatal accident on the Q&TL occurred on November 15, 1937. The railroad itself had been shut down since 1931, and it was just getting back into operation in 1937 to meet the demands of World War II. Very little maintenance had been done in the years prior to 1931, and this earlier neglect plus six years of inactivity may have contributed to the trestle collapse that crushed the cab of No. 5. The remains of the cab can be seen in the ditch, broken in half and completely separated from the rest of the engine. What does remain of the tender is just barely visible and badly crushed by the momentum of the loaded rock cars. (George E. Anderson collection.)

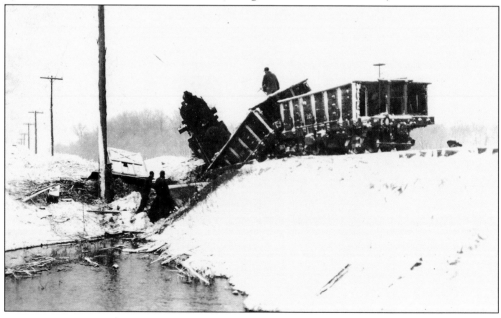

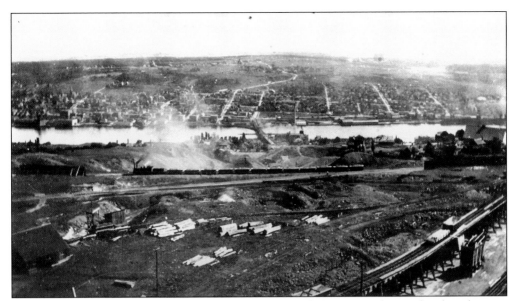

This bird's-eye view of the Quincy Hill shows a fully loaded 12-car rock train heading down to the mills on Torch Lake six miles away. The down-bound rock trains were given odd numbers while the up-bound coal trains were assigned even numbers. Although the train operations seemed quite simple, there were at least 15 forms that had to be filled out daily and several for each train. (George E. Anderson collection.)

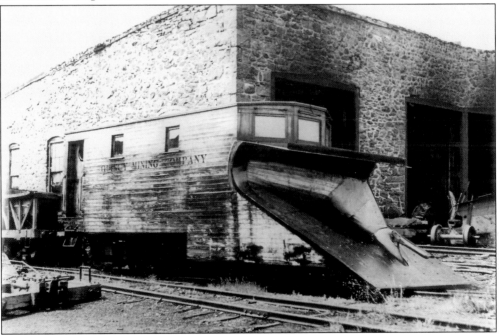

Next to the Q&TL roundhouse sits its Russell snowplow lettered for the Quincy Mining Company rather than for the railroad itself. It appears that the plow was not painted but was coated with a transparent varnish that allowed the wood grain to show through, then overlaid with black lettering, which seemed to be a fairly common practice employed by the Russell Plow Company of Ridgeway, Pennsylvania. (George E. Anderson collection.)

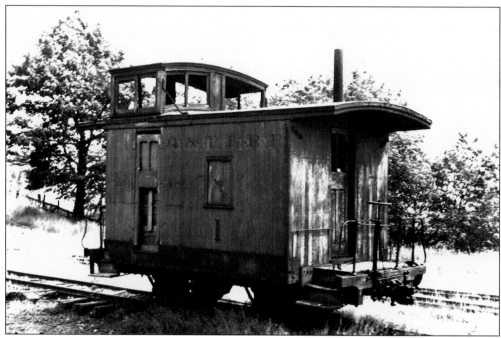

This photograph of Q&TL caboose No. 1 is from August 1942, near the end of operations in 1945. The little four-wheel bobber was originally built by the Peninsular Car Company of Detroit in 1889 without the cupola, which was added at a later date. The car was probably painted orange, which was common practice in the Copper Country to distinguish a caboose from the red rock cars. (George E. Anderson collection.)

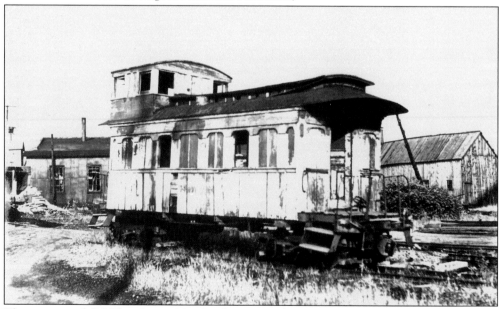

This picture of Q&TL caboose No. 04 shows it to be in pretty bad shape near the end of operations in World War II. It was originally built in 1873 as a passenger coach for the Mineral Range Railroad. It was shortened by one window at each end, and the cupola was added and it was used as a caboose on the Q&TL. (George E. Anderson collection.)

Six

LOCAL STANDARD-GAUGE LINES

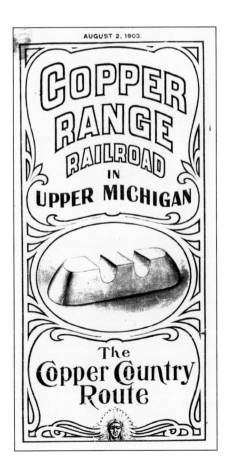

The Copper Range Railroad was first conceived by Charles Wright, manager of the Mineral Range Railroad. In 1889, he incorporated the Northern Michigan Railroad, but it took until 1898, when he secured the help of William A. Paine of Paine, Webber and Company to capitalize the project. The concept was that the "South Range" would be as productive in copper values as the Quincy or Calumet and Hecla lodes. This bold, August 1903 timetable shows that the "Copper Country Route" was the line of choice to the cities of the south. (Houghton County Historical Society Archives.)

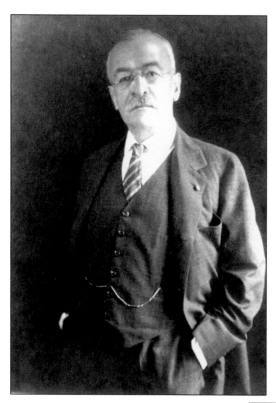

William Alfred Paine was born January 28, 1855, in Amesbury, Massachusetts. He began his career in finance in 1873 as a clerk at a bank in Boston. In 1880, with a loan from his father, he partnered with Wallace G. Webber to create the brokerage firm Paine, Webber and Company, members of Boston and New York Stock Exchanges. After running his highly successful brokerage business for nearly 50 years, Paine died just a few weeks before the Wall Street crash of 1929. (MTU Archives and Copper Country Historical Collections, Michigan Technological University.)

Paine, the founder of the Copper Range Consolidated Copper Company, the Copper Range Railroad, and also a principal and founder in the firm of Paine, Webber and Company chats with the train crew in this 1912 photograph. Behind the locomotive is a passenger train including the *Miscowaubic*, one of the Copper Range Railroads business cars designed for such occasions. (MTU Archives and Copper Country Historical Collections, Michigan Technological University.)

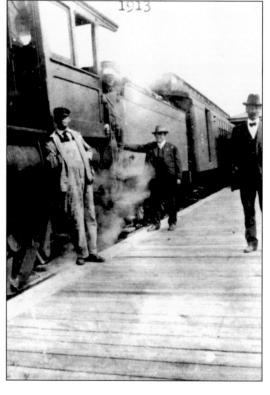

Of the three mining properties of the Copper Range Company, the Champion shafts, located in Paine's namesake town of Painsdale, were both the most productive and the longest operating. The Copper Range Railroad was fully integrated into the mining location here at Champion "D" shaft and the others. Note the ore-loading track under the rock bin to the right of the miner in the foreground. (MTU Archives and Copper Country Historical Collections, Michigan Technological University.)

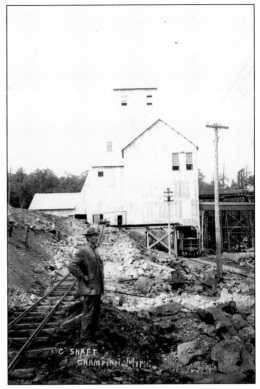

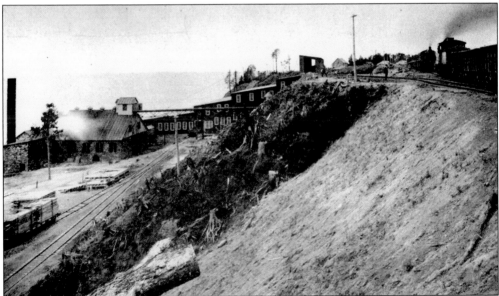

This is an image of the early Champion Mill at Freda (named after Paine's daughter). The Lake Superior shoreline is on the left of the picture. One Copper Range train has arrived with a string of rock cars with either ore or coal aboard. Another locomotive has been turned (facing the reader) and is ready to head back to Mill-Mine Junction and the mines beyond or a load of copper concentrate for the smelter. (MTU Archives and Copper Country Historical Collections, Michigan Technological University.)

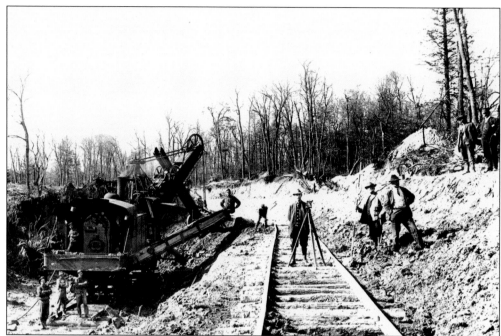

Local photographer J. W. Nara documented much of the construction of the Copper Range Railroad in the 1890s through the early 1900s. Here a steam shovel crew operates one of the Copper Range's Bay City steam shovels on the construction of the Painesdale extension in 1913. Note the survey crew standing on the main track to the right of the shovel. (MTU Archives and Copper Country Historical Collections, Michigan Technological University.)

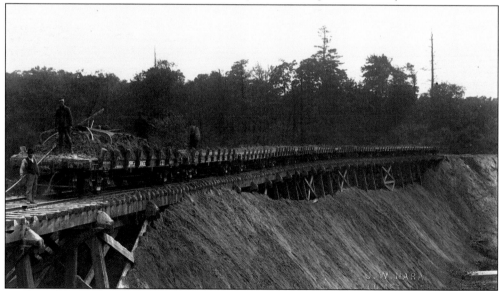

A string of sand-laden flatcars, with staked boards for sides to contain the fill, are used to fill a trestle on the line. This technique was a widely accepted railroad engineering practice for years as it made stream, swale, and even open shallow water crossings easier without the use of heavy equipment. This scene is from the Painesdale extension in 1913. (MTU Archives and Copper Country Historical Collections, Michigan Technological University.)

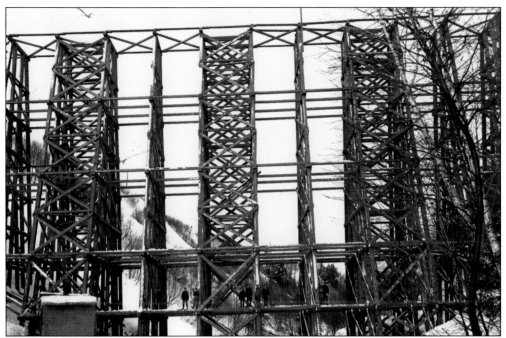

Before the steel trestlework was installed bridging the Firesteel River branches, great wooden bridges were erected to facilitate the erection of the steelwork. Here is one of the structures. An engineering art form completely fabricated from wood (usually virgin eastern hemlock), these trestles could handle the traffic until the heavier steel bridge was completed. This photograph dates from 1899. (MTU Archives and Copper Country Historical Collections, Michigan Technological University.)

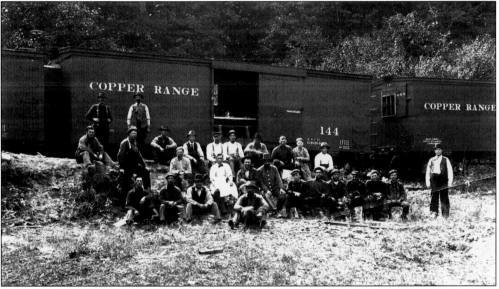

During its construction and subsequent additions, the track and construction gangs of the Copper Range had to be quite self sufficient, as they worked quite far from civilization. Here a group of track workers gathers for lunch outside the cookshack car on a job site in the early 1900s. (MTU Archives and Copper Country Historical Collections, Michigan Technological University.)

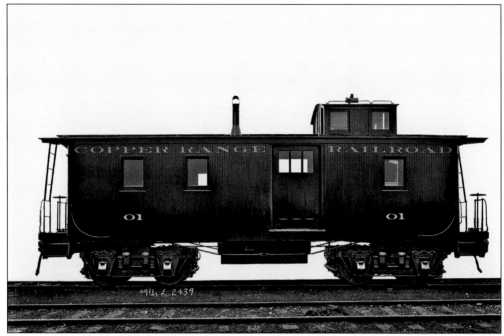

Copper Range Railroad caboose No. 01 was built by Pullman in 1899 as lot No. 2439. It was a large, six-window, side–baggage door caboose equipped with smooth riding passenger trucks for the comfort of the crew. At least 34 feet long, this was probably the largest and best-riding caboose on the roster since many of the later ones were small four-wheel bobbers that were notoriously rough riding. (Smithsonian Institution, National Museum of American History.)

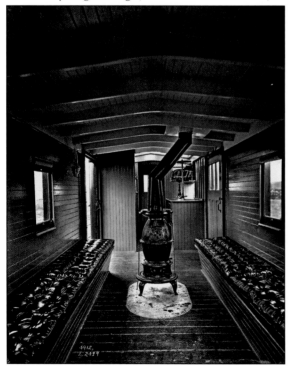

The interior of caboose No. 01 was equipped with a central stove for heat during the long, cold winters and plush leather cushioned benches down each side to accommodate the transportation of the crews in relative comfort during construction of the railroad. It was replaced in September 1917 by a steel-underframe 30-foot-long caboose, No. 01, with eight windows and no side baggage doors. (Smithsonian Institution, National Museum of American History.)

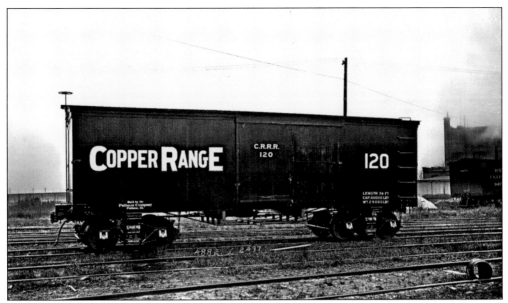

Copper Range boxcar No. 120 is one of 50 built by Pullman in November 1899, as lot No. 2437. They were 34-foot cars weighing 29,000 pounds and numbered from 101 to 150. For reasons that have not been recorded, 39 of the cars were sold the following year by general manager R. T. McKeever, leaving the railroad with only 11 boxcars. (Smithsonian Institution, National Museum of American History.)

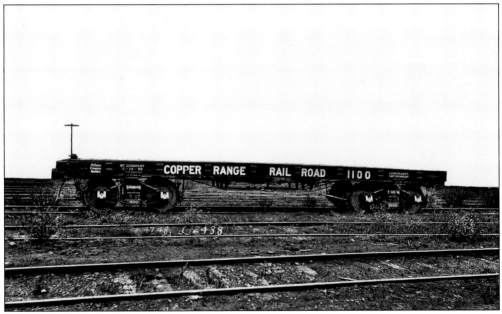

Copper Range flatcar No. 1100 was one of 100 flatcars built by Pullman on July 13, 1899, as lot No. 2438. They were 34-foot cars weighing 22,600 pounds and numbered from 1001 to 1100. The railroad used flatcars extensively during construction of the roadbed and in the shipping of copper ingots and cakes from the smelter to the docks. (Smithsonian Institution, National Museum of American History.)

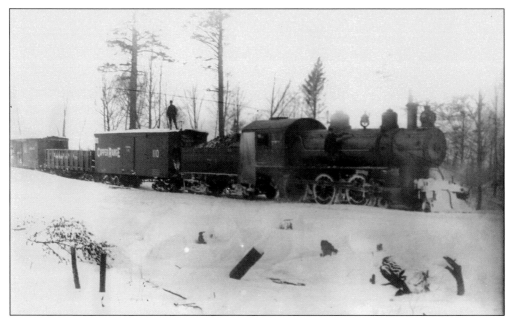

Copper Range Railroad engine No. 51 was a Class T-1, 4-6-0 Baldwin C/N 17272 built in December 1899. It was retired in November 1922 and sold to Harry P. Bourke of Escanaba. The boxcar No. 110 behind the engine was one of the 50 cars built for the Copper Range by Pullman in 1899. All but 11 cars were sold the following year, and those remaining were numbered from No. 100 to No. 118. (Superior View Studio/Jack Deo collection.)

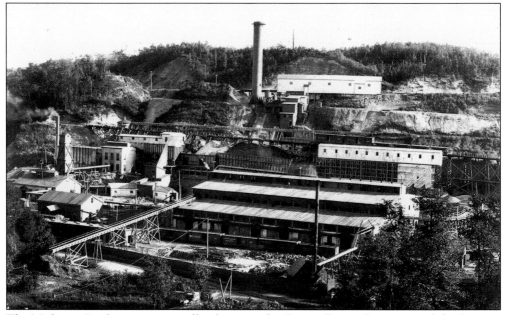

The Michigan Smelter was a joint effort between the Copper Range Company and the Stanton Group of mines, which included the Atlantic, Wolverine, and Mohawk with the smelter being located near the former location of the Atlantic Mill on Cowles Creek, west of Houghton on Portage Lake. Built in 1903, the smelter was still operating through World War II, glowing red 24 hours a day for the war effort. (Greenfield Village and the Henry Ford Museum Collections.)

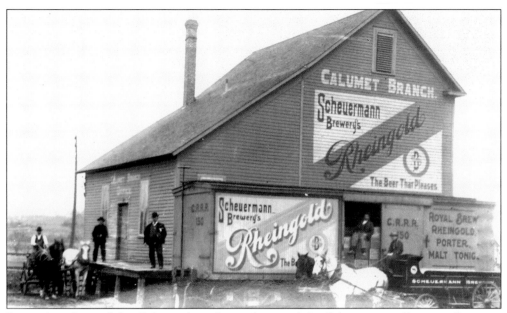

Pictured in front of the Calumet branch warehouse of the Scheuermann Brewing Company is the Copper Range boxcar No. 150 sporting Rheingold lettering. It was one of the original 50 cars built by Pullman in November 1899. It was probably painted with Rheingold lettering about 1905 when it was car No. 118, and then painted again and renumbered in 1910 when it became car No. 150. Scheuermanns Brewing Company was owned by Bosch since 1900. (MTU Archives and Copper Country Historical Collections, Michigan Technological University.)

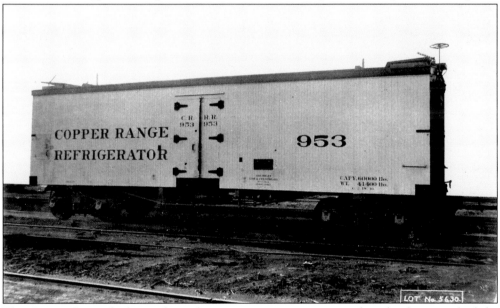

The Copper Range had very few refrigerator cars, starting out with eight that were built by Pullman in 1899. Four more refrigerator cars were added in 1910, like No. 953 shown here. These last four cars were ordered from American Car and Foundry in Chicago on September 3, 1909, as lot No. 5630. They were completed on February 18, 1910, and had a capacity of 60,000 pounds and weighed 41,400 pounds. (George E. Anderson collection.)

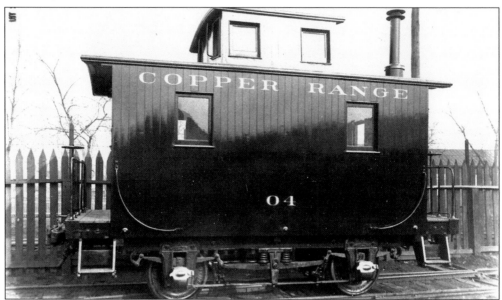

Copper Range Railroad caboose No. 04 was built by American Car and Foundry in its Jeffersonville, Indiana, facility on October 13, 1902. There were two of these four-wheel bobbers built in American Car and Foundry lot No. 2510. The railroad seemed to like the little four-wheel cars as they comprised almost half the caboose fleet. It was customary for the railroad to place a zero before the number on its caboose and maintenance of way equipment. (George E. Anderson collection.)

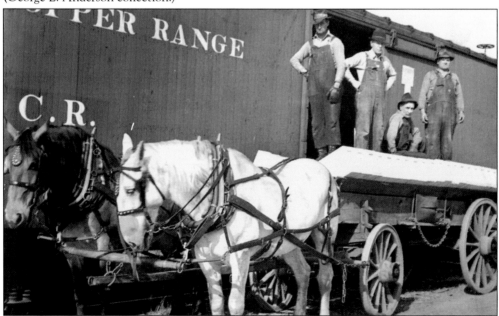

A group of teamsters is unloading a Copper Range wood boxcar at the team track in Houghton around 1912. Freight loading at the beginning of the 20th century was backbreaking work and went on in sweltering summer heat or icy winters. The railroad term for an open track for freight handling was "team track," after the teams of horses, such as these, seen at the side of the freight cars. (Houghton County Historical Society Archives.)

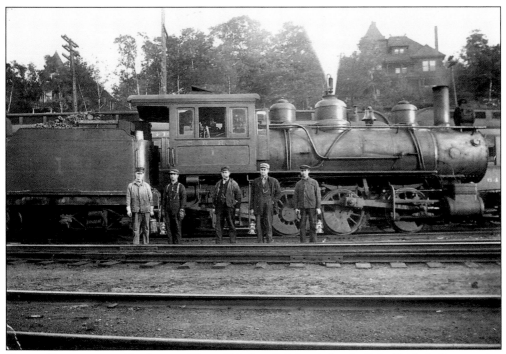

Copper Range engine No. 1 was a 74-ton S-1 class 0-6-0 switcher built by Baldwin Locomotive Works in September 1899 as C/N 16995. Posed here with its crew, it lasted in service until being retired in January 1928 but was not sold for scrap until November 1935. It was a common practice on the Copper Range for such equipment to remain on the property but unused for many years. (George E. Anderson collection.)

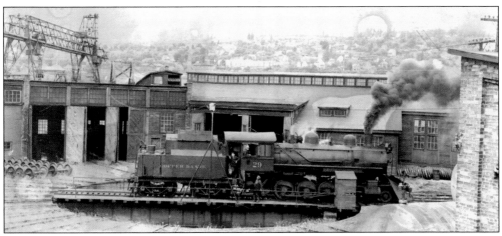

Copper Range 2-8-0 Consolidation No. 29 sits on the turntable at Houghton in the mid-1940s. This engine, and its sister No. 26, ran on the line until 1953 but, unlike No. 26, No. 29 was not scrapped and was stored until taken over in 1967 by Trans-Northern, which ran a tourist train on the line from Lake Linden to Calumet until 1970. This locomotive is now restored at Mid-Continent Railway Museum in North Freedom, Wisconsin. (MTU Archives and Copper Country Historical Collections, Michigan Technological University.)

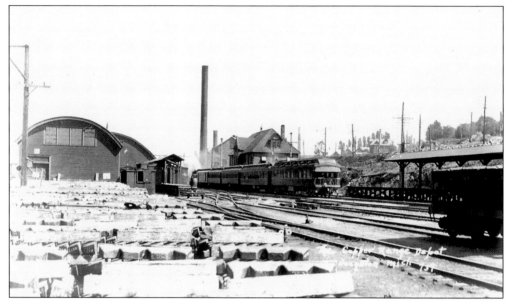

A five-car Copper Range Railroad passenger train is all steamed up and waiting to leave from the Copper Range depot in Houghton. The dock in the left foreground is stacked with tons of copper ingots, waiting to be loaded on a steamship for transport to markets in the southern Great Lakes. The docks and yards are long gone, but the depot has been restored and is still in use today. (David D. Tinder, William L. Clements Library.)

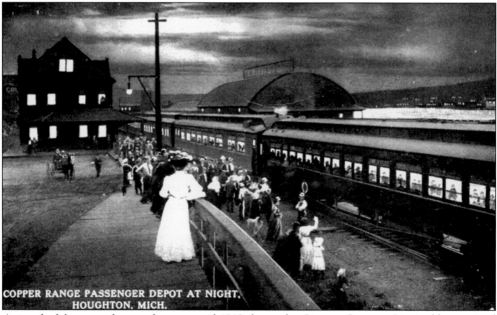

A wonderful postcard scene from around 1910 shows the Copper Country Limited has arrived at Copper Range Union Depot in Houghton in the moonlight with the cars of the train lit up and with friends and relatives awaiting the disembarking passengers. The Portage Lake is in the background, and the train will go on from here to Hancock and then Calumet, after crossing the swing bridge over the lake to the right out of the picture. (Houghton County Historical Society Archives.)

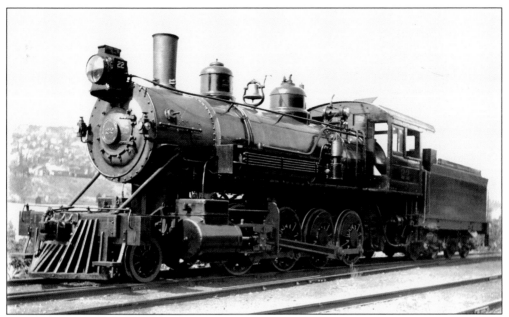

Copper Range Cosolidation No. 22 was the first of three steam locomotives bought from the Baldwin Locomotive Works at Philadelphia. Received between August and December 1899, the engines were used on the Copper Range for many years. Sold to the Green Company for scrap, the engine was wrecked along with its sister engine, No. 21, while on the way to the scrapping yards at Ripley in 1921. (Houghton County Historical Society Archives.)

The Copper Range ran both eight-wheel and four-wheel bobber cabooses on its freight and mixed trains. This caboose—with its side "less-than-load" door—is typical of the eight-wheel "crummies." They were typically painted either red or, in later years, orange. (MTU Archives and Copper Country Historical Collections, Michigan Technological University.)

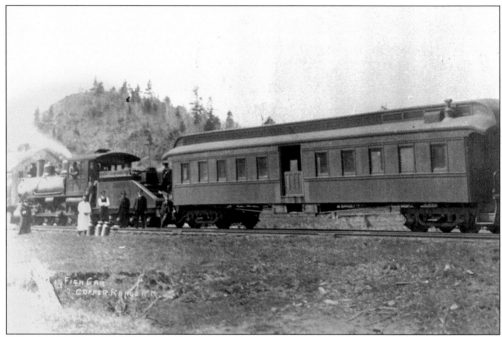

The Copper Range Railroad apparently had a "fish car," which, it is presumed, was used for transporting live fish to restock streams and lakes along its right-of-way. The origin of this photograph is unknown, as is the number of the wooden coach, but it dates from the early 1900s. (Houghton County Historical Society Archives.)

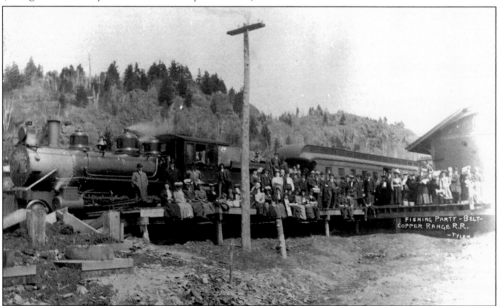

The Copper Range ran a wide variety of excursions and local trains in the days before trolleys (Houghton County Traction), automobiles, and the roads that grew up to serve them killed this practice. These excursions were often a main way that folks could reach the backcountry to enjoy its fishing, hunting, and scenery. Here is a photograph from an unknown photographer showing a fishing excursion in the early 1900s. (Houghton County Historical Society Archives.)

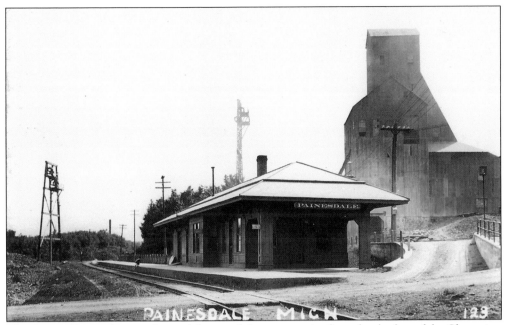

The Copper Range depot at Painesdale served the community from the shadow of the Champion No. 4 shaft house for many years. The railroad station is now long gone, but the shaft house and its equipment have been preserved because the equipment was being used to pump the city water for Painesdale from the hoist house at the mine. (George E. Anderson collection.)

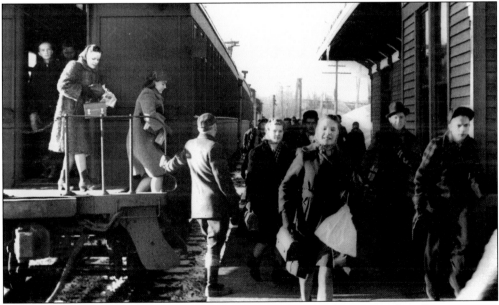

From around 1908 until 1941, the Copper Range sought to underwrite its dwindling passenger traffic with a "School Special" that transported students to Adams Township Schools based in Painesdale. For years, public school students from as far away as Freda, Atlantic Mine, and South Range rode the train daily until replaced by bus service in 1941. Here students disembark the train in 1939 at Painesdale. (MTU Archives and Copper Country Historical Collections, Michigan Technological University.)

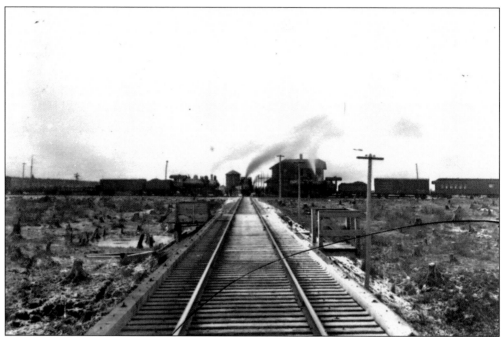

Mill-Mine Junction, pictured here by Adolph F. Isler in 1905, was created as a point where trains outbound from Houghton would travel either southeast to South Range and the mining district (Baltic, Trimountain, Painesdale) or west to the stamp mills at Beacon Hill, Freda, or Freda Park via Redridge. The freight on the left sits on the original Copper Range Railroad main line, which was closed after 1913. (MTU Archives and Copper Country Historical Collections, Michigan Technological University.)

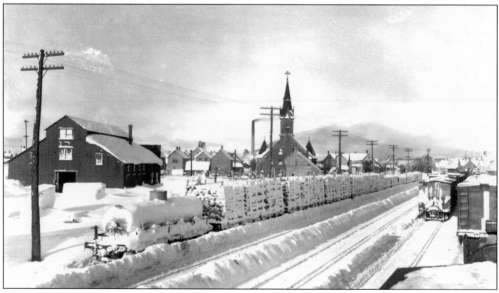

Frozen water vapor from coal burning furnaces hovers over the Calumet yard in the late 1940s. The winged snowplow has recently cleared the tracks and a string of flatcars loaded with pulpwood logs and a lone oil tank car are waiting to be picked up. (MTU Archives and Copper Country Historical Collections, Michigan Technological University.)

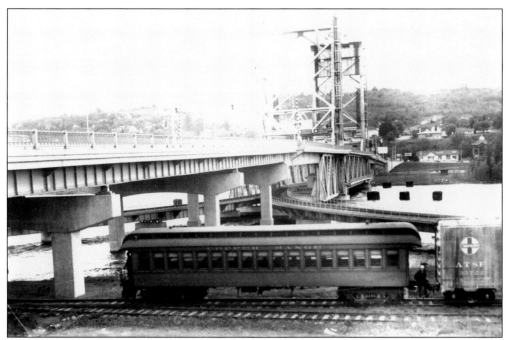

In this 1964 photograph by Earl J. Gagnon, the last passenger car, Copper Range No. 60, a coach, is leaving for Marquette on the Soo Line Railroad (former DSS&A) to be part of a tourist line. The Marquette and Huron Mountain Railroad operated in the Marquette area in the mid- to late 1960s but never really made a success of its operation. (MTU Archives and Copper Country Historical Collections, Michigan Technological University.)

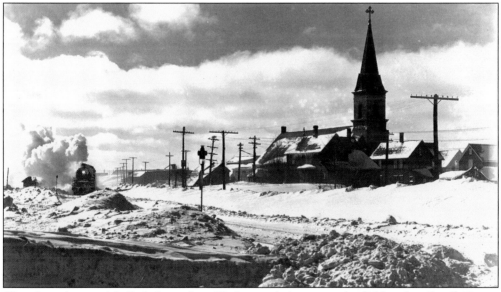

"One hour late and ballin' the jack at 20 degrees below zero, the [Milwaukee Road] *Copper Country Limited* arrives at Calumet around 10:30 AM" writes photographer Wendell J. Kraft of this winter shot taken in 1947. The high stepping 4-6-2 Pacific puts on quite a steam and smoke show for the camera in the cold winter air. (W. J. Kraft photographer, Houghton County Historical Society Archives.)

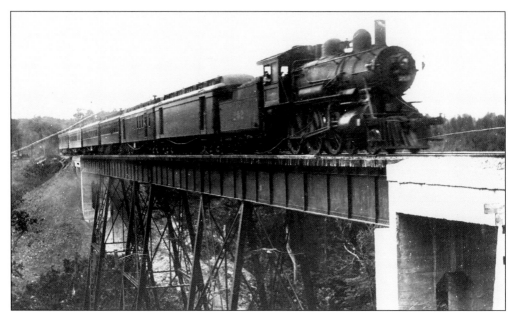

The Milwaukee Road Copper Range Limited, on bridge No. 2 in 1913, on its way to Houghton from McKeever, had three major river valleys to cross. The Firesteel River valleys required trestles ranging in height from 65 to 85 feet, totaling over 1,290 feet, and built of steel. Most of the other stream crossings on the Copper Range Railroad were crossed during construction with wooden trestles, which were eventually buried in fill. (MTU Archives and Copper Country Historical Collections, Michigan Technological University.)

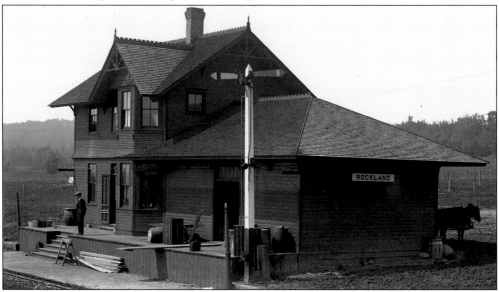

The Chicago, Milwaukee and St. Paul Railroad combination passenger and freight depot at Rockland boasted second-floor living quarters for the agent and family. Rockland was the site of the Minnesota Mine, one of the first mass copper mines in the South Range and one of the most successful in the pre–Civil War era. The mine was briefly reopened in the 1880s with enough output to justify continued rail service. (MTU Archives and Copper Country Historical Collections, Michigan Technological University.)

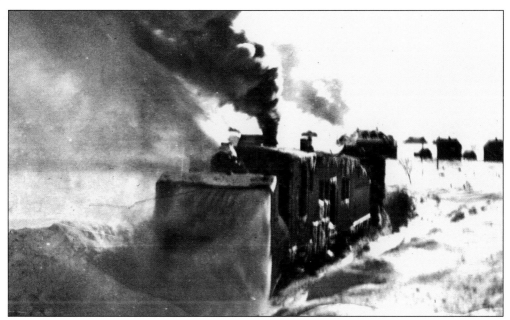

J. W. Nara, the photographer on these shots, along with Adolph F. Isler, captured the life and times of the early 20th century in the Copper Country. Here Nara photographed the inaugural run of the Copper Range Railroad rotary snowplow No. 9 built by American Locomotive Company–Cooke's works No. 56162 in December 1917. The unit was delivered to Houghton along with two new American Locomotive Company–Pittsburgh 2-8-0s during the United States Railway Administration's control of the Copper Range during World War I. The snow conditions on the line were variable, however, and the cost to maintain and operate the rotary exceeded its utility. The unit was eventually sold to the Laramie, North Park and Western Railroad, a Union Pacific subsidiary, and there it was finally retired in 1983. It is now on display in Hanna, Wyoming. (MTU Archives and Copper Country Historical Collections, Michigan Technological University.)

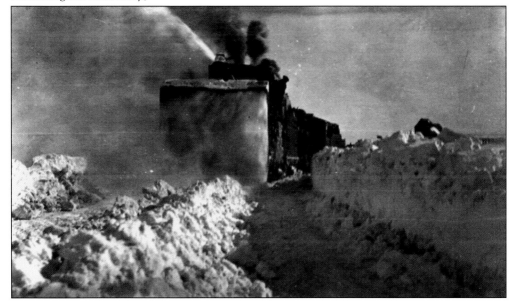

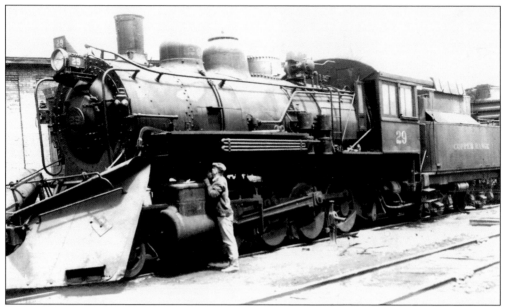

A photograph dating from the late 1930s shows a mechanic inspecting Copper Range Railroad 2-8-0 No. 29 before it heads out on a revenue run. An American Association of Railroads (AAR) boxcar with dreadnought ends appears to be coupled to the locomotive tender. The Copper Range left the pilot wedge plows on year-round. (MTU Archives and Copper Country Historical Collections, Michigan Technological University.)

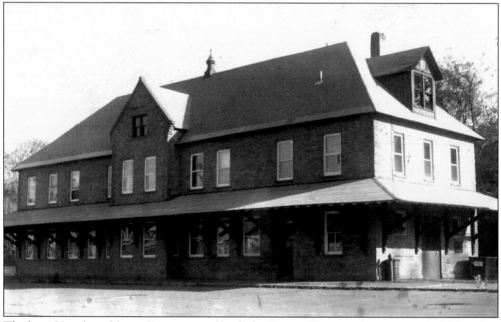

The large Houghton Union Station served both the Copper Range and its partner the Milwaukee Road (also known as the Chicago, Milwaukee, St. Paul and Pacific Railroad). In the upper floors, it housed the main offices of the railroad. The depot was built by the Copper Range, completed in 1900, and is still in commercial use today. (MTU Archives and Copper Country Historical Collections, Michigan Technological University.)

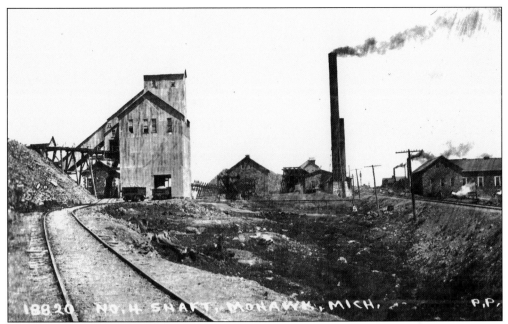

The Mohawk Mine was originally served by the Mohawk and Traverse Bay Railroad, which was owned by the mining company. The railroad served the Wolverine Mine in Copper City and the Mohawk Mine in Mohawk and hauled ore to the mill on Keweenaw Bay at Gay. This line was taken over by the Copper Range when it leased the former Keweenaw Central Railway line from Calumet Junction to Nichols near Copper City in 1918. (MTU Archives and Copper Country Historical Collections, Michigan Technological University.)

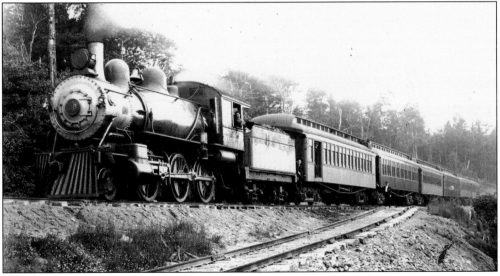

The Copper Range local passenger trains were typically made up of a consist of one of the Copper Range 4-6-0s, in this case No. 60, a combine No. 26 (rebuilt from a smoker coach by the Copper Range shops) and one to four wooden coaches of indeterminate numbers. Here the conductor (Charles Avery) stands by the combine, which carried baggage and less-than-load freight to travel between towns on the line. (MTU Archives and Copper Country Historical Collections, Michigan Technological University.)

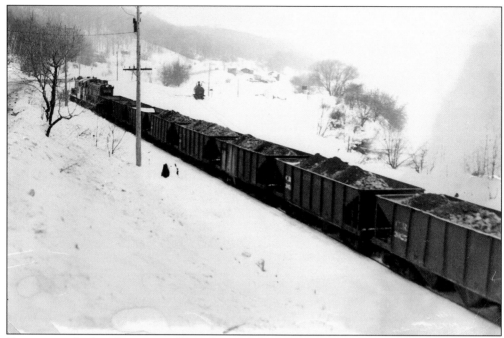

Snow-covered piles of copper ore fill steel ore cars as engines No. 100 and No. 101 pull a trainload of ore to the Freda Mill on the Lakeshore branch. The Copper Range Railroad had three of these Baldwin locomotives Nos. 100, 101, and 200. No. 200 has been preserved by the Soo Line Historical and Technical Society and is now at the Lake Superior Transportation Museum at Duluth, Minnesota. (MTU Archives and Copper Country Historical Collections, Michigan Technological University.)

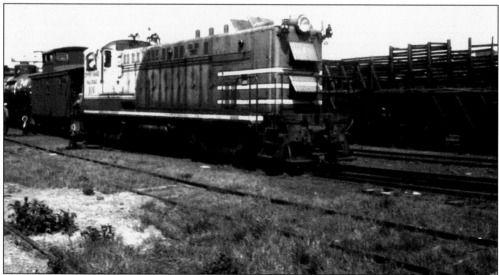

No. 100, its unique characteristic the large shutter doors on its radiator grill, is a Baldwin model DS4-4-1000. With its sister No. 101, it served the railroad until abandonment in October 1972. Here it is seen switching near the old coal dock. Both No. 100 and No. 101 were sold to the New Hope and Ivyland Railroad, and then SMS Rail Services in New Jersey. The No. 100 was scrapped with a broken crankshaft. (Houghton County Historical Society Archives.)

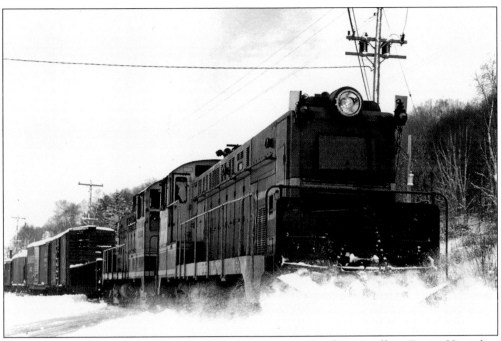

Copper Range No. 100 and No. 101 often were run as a "push-me, pull-you" pair. Here they are bucking an evening's snowfall, heading toward Houghton in the 1960s. Even though the photograph was undated, it can be dated from after 1966 because the units lacked multiple unit capability before that date. (Houghton County Historical Society Archives.)

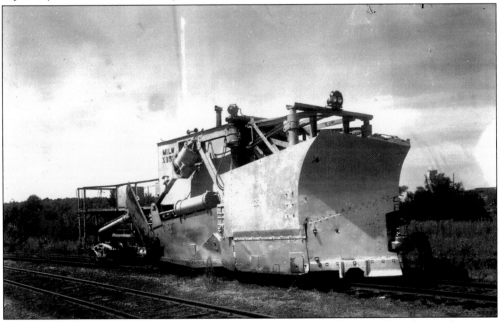

The Copper Range, throughout its years of operation, cooperated intensely with its rail partner, the Milwaukee Road. In this Edwin Batchelder photograph from the 1960s, a Milwaukee Road plow flanger was photographed on the Copper Range tracks near McKeever. (MTU Archives and Copper Country Historical Collections, Michigan Technological University.)

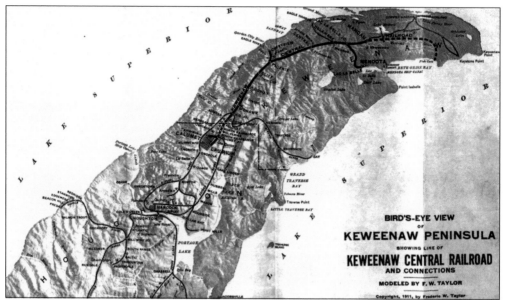

This Keweenaw Central Railway map was published in 1911 and shows the extent of the railroad and its projected routes in dotted lines. The line shares trackage with the Copper Range Railroad into Calumet and used the Copper Range Pine Street station. After closing for winter in 1917, the line never reopened. The Calumet and Hecla Consolidated Mining Company bought the Keweenaw Copper Company in 1918. The railroad was abandoned north of Phoenix and the rails torn up. (MTU Archives and Copper Country Historical Collections, Michigan Technological University.)

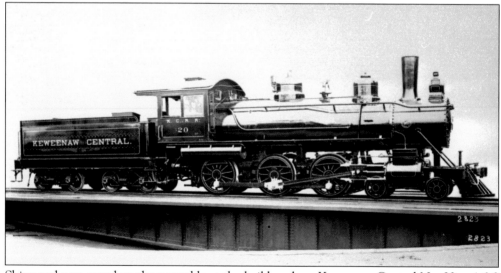

Shiny and new, posed on the turntable at the builders shop, Keweenaw Central No. 20, a 4-6-0 Mogul awaits delivery in 1905. The locomotive was bought to run on the regauged line of the Lac LaBelle and Calumet Railroad, which used to serve the Delaware Mine and the Lac LaBelle stamp mill. The line was bought by the parent Keweenaw Copper Company with hopes that better transport and mining techniques would yield another lode like the Quincy or C&H mines. (MTU Archives and Copper Country Historical Collections, Michigan Technological University.)

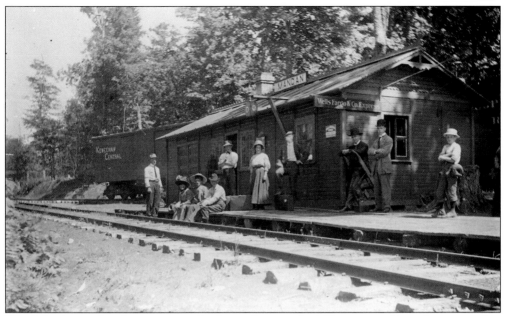

The Mandan railroad station was built to the standard Keweenaw Central station plan and also houses a Wells Fargo and Company Express office. A crowd of men, women, and children are waiting on the platform for the next train to arrive. One can catch a glimpse of a Keweenaw Central boxcar to the left, behind the station, and a Copper Range boxcar to the right of the building. (MTU Archives and Copper Country Historical Collections, Michigan Technological University.)

The depot at Mandan in the summer presents a very bucolic scene in this picture. Mandan was originally a small mass mining settlement during the early boom days, and then in the early 1900s, there was extensive exploration in the area by the Keweenaw Copper Company with hopes of exploiting the geology of the area. Today Mandan is a ghost town. (MTU Archives and Copper Country Historical Collections, Michigan Technological University.)

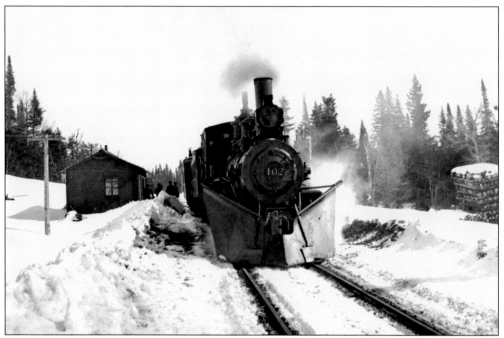

Keweenaw Central Railway No. 102 is seen here in winter, near what appears to be Mandan depot. This undated photograph shows the old 4-4-0 wearing a huge steel V plow for bucking the snow. These were standard winter equipment for the majority of steam locomotives operating in the Copper Country winters, which brought over 250 inches of snow in a season. (MTU Archives and Copper Country Historical Collections, Michigan Technological University.)

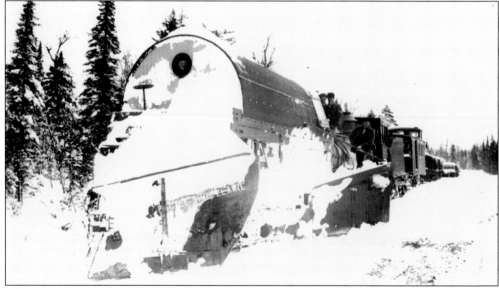

This gargantuan plow was lovingly called *Battleship Elaine* and was essential to clear the huge snowfalls that plagued winter operation on the Keweenaw Central. Made entirely of riveted iron with a huge wedge plow on the front end and side mounted wing plows on both sides, the big girl really did the job. Note the operator's porthole window in the front of the tank-shaped body. (MTU Archives and Copper Country Historical Collections, Michigan Technological University.)

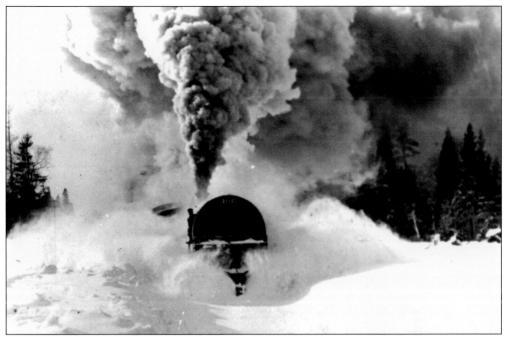

As one can see from the column of smoke and ash, the locomotive is working hard to push *Battleship Elaine* through the drifts. Snow is flying 10 to 20 feet along either side of the tracks. This photograph dates from around 1912. (MTU Archives and Copper Country Historical Collections, Michigan Technological University.)

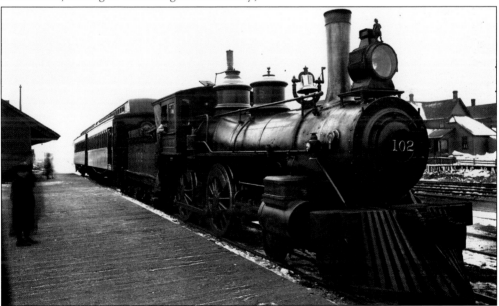

Keeweenaw Central No. 102, a 4-4-0, was built by the Taunton Locomotive Works of Massachusetts in 1882 and acquired from the Northern Pacific Railway by the Copper Range Railroad in 1899 and then sold to the Keweenaw Central in 1906. It sits here quietly cooking on a late-winter morning at the Pine Street Depot in Calumet on the Copper Range with its local passenger train. (MTU Archives and Copper Country Historical Collections, Michigan Technological University.)

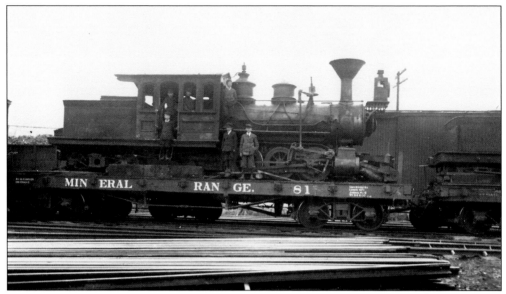

This little three-foot narrow-gauge Mason Bogie was captured by the camera in 1911, as it passed through the yards in Calumet loaded on a standard-gauge Mineral Range Railroad flatcar. The photographer noted that this was an old Keweenaw Central Railway engine. The northern end of the railroad down to the mill at Lac LaBelle was finally standard gauged about this time, and the narrow-gauge equipment became surplus. (Glen Marshall collection.)

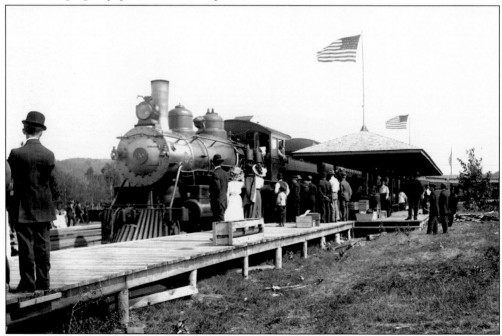

The platform at the Crestview Resort and Casino is loaded with passengers from the long string of coaches trailing off into the distance behind Keweenaw Central engine No. 20. Adolph F. Isler took these photographs at the grand opening of the resort in 1909. Note the American flags standing out in the stiff breeze off the lake. (MTU Archives and Copper Country Historical Collections, Michigan Technological University.)

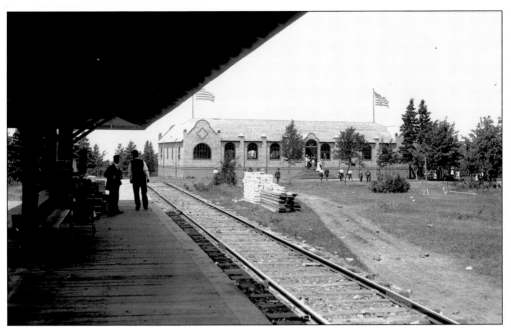

The Crestview Resort and Casino, north of Phoenix on the Keweenaw Central, was built to provide an end-of-line destination for excursion trains popular around the beginning of the 20th century. The not-so-rustic casino, dance pavilion, dining hall, and other amenities were typical of the entertainments of the Edwardian age. The Keweenaw Central met the Copper Range Railroad at Calumet Junction, allowing the Copper Range passengers to enjoy excursions to the resort. (MTU Archives and Copper Country Historical Collections, Michigan Technological University.)

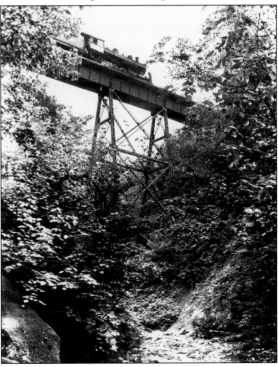

This 1968 view of the new Keweenaw Central train crossing the former Copper Range No. 30 steel trestle bridge high over Hammell Creek was a popular postcard. The sounds of steam barking from the stack as No. 29 negotiated the 1.8-percent grade on St. Louis Hill are long gone from the Copper Country railroads, although the engine has been restored at North Freedom, Wisconsin. (Houghton County Historical Society Archives.)

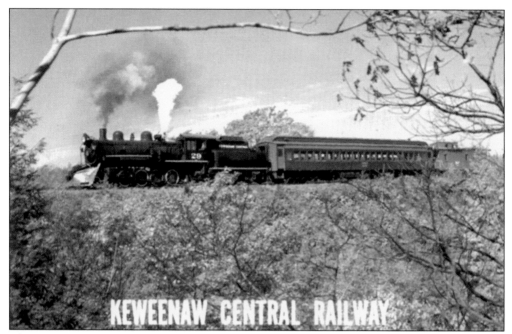

These are postcard views from the "new" Keweenaw Central Railway, a small freight and tourist operation founded by a small group calling itself Trans-Northern and lead by Clinton Jones. The group purchased and refit Copper Range Railroad 2-8-0 No. 29 and coach No. 60. They also purchased the Copper Range line from Lake Linden to Calumet. Included in the purchase was the spectacular No. 30 steel trestle bridge (1910) over Hammell Creek, the source stream for Douglass Houghton Falls. The postcard image below shows No. 29, coach No. 60, and a former Copper Range caboose crossing the trestle above the creek. Unfortunately when No. 29 required repairs in 1970, the line switched to a former Chicago, Burlington and Quincy Railroad (Burlington) motorcar, which simply did not appeal to the tourists. The railroad closed in 1971, and its equipment was hauled to Ripley for storage. (Houghton County Historical Society Archives.)

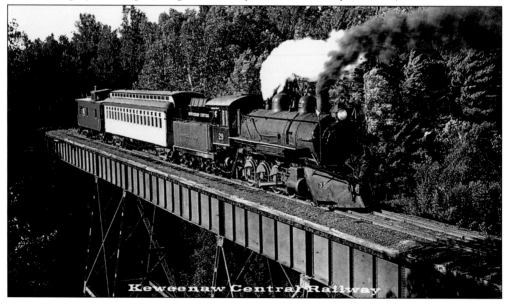

Seven

SPECIAL INDUSTRIAL RAILROADS AND ELECTRICS

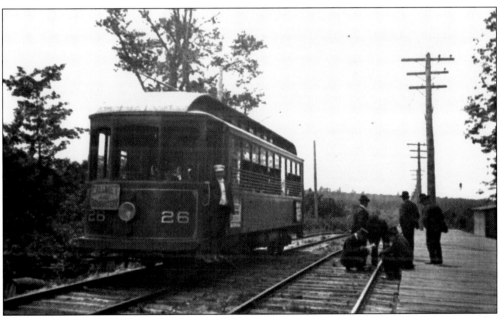

The Houghton County Traction Company's Calumet-to-Houghton express car No. 26 is on the express track at Electric Park. A group of several men seems to be inspecting the rails on the siding. The low platform saw many happy passengers coming to and leaving from the amusement park. (MTU Archives and Copper Country Historical Collections, Michigan Technological University.)

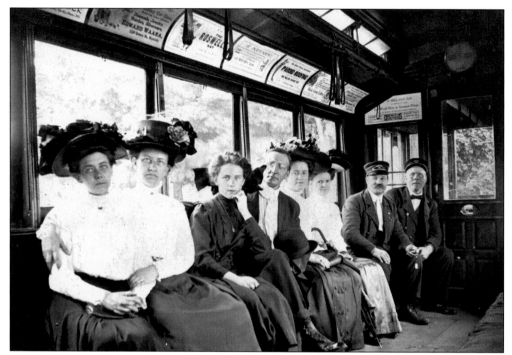

Inside the streetcar that runs between Laurium and Lake Linden in this vintage scene, the ladies are dressed in their Sunday best, as is the gentleman in the center with his white tie and bowler hat. Even the conductor and the motorman are dressed to the hilt with their neckties in evidence. Several of the interesting vintage advertisements are visible in the cove above their heads. (MTU Archives and Copper Country Historical Collections, Michigan Technological University.)

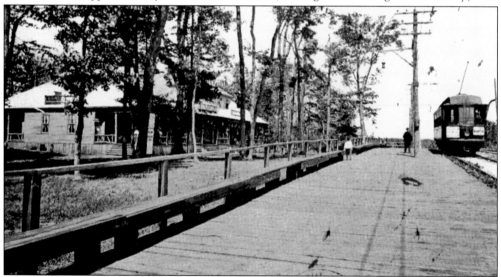

Electric Park was established by the Houghton County Street Railway as a destination point just north of Boston Township, on the line between Hancock and Calumet, to encourage ridership and is shown on this card that was postmarked August 12, 1909, in Laurium. The interurban trolley cars could often be seen carrying a large placard announcing the dance, or "promenade," and the featured band for the next Saturday night. (George E. Anderson collection.)

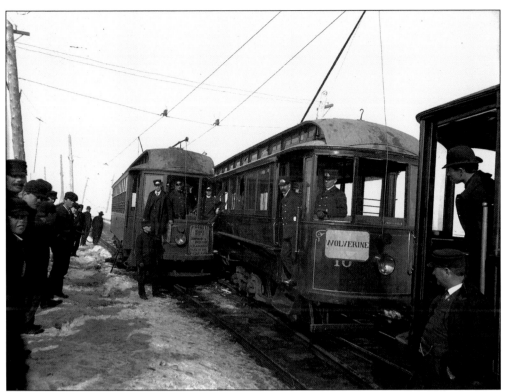

This early-1900s photograph reflects every trolley man's nightmare. The two cars pictured appear to have had a collision due to the No. 10 car being too close to the "fouling point" of a switch. It appears the accident drew a crowd and a photographer. One of the cars bears a route sign for Wolverine. The other poster touts "Hockey! Pittsburg vs Portage Lake, 2 games at the Palace Ice Rink, Monday and Tuesday, March 10 and 11." (MTU Archives and Copper Country Historical Collections, Michigan Technological University.)

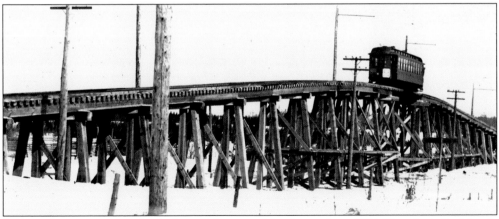

A through car moves southerly from Calumet to Houghton about 1917. The site is St. Mary's, named for the St. Mary's Mine and the Mineral Land Company. The site today is said to be immediately south of Boston Township. The lone car, which was called a trolley-interurban, travels the wooden trestle in winter. (MTU Archives and Copper Country Historical Collections, Michigan Technological University.)

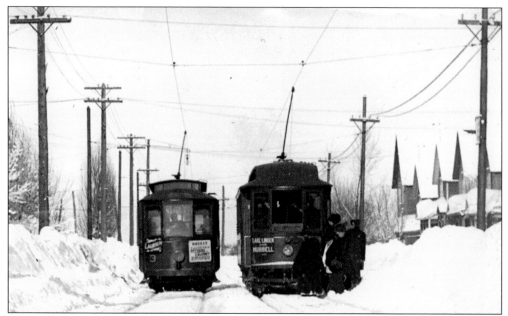

Two streetcars pass in the Calumet area. One of the cars has a route sign reading "Lake Linden and Hubbell" the other reads "Laurium." Several people are standing in line waiting to board the Lake Linden car. The Laurium car also has a sign promoting a hockey game between teams from Calumet and Pittsburg. Houghton's Amphidrome Arena is the acknowledged home of American professional hockey. (MTU Archives and Copper Country Historical Collections, Michigan Technological University.)

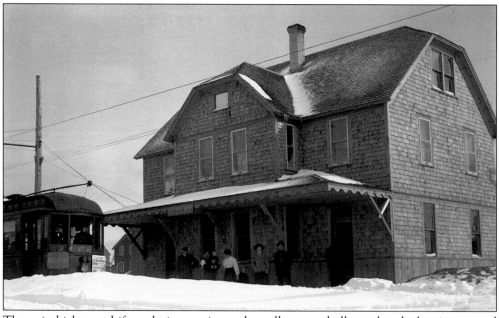

The waist-high snowdrifts make just getting to the trolley car a challenge, but the line is open and the streetcar bound for Red Jacket (Calumet) is just pulling into the wooden shingled Mohawk Streetcar Station to pick up the group of passengers that is gathered on the platform. (MTU Archives and Copper Country Historical Collections, Michigan Technological University.)

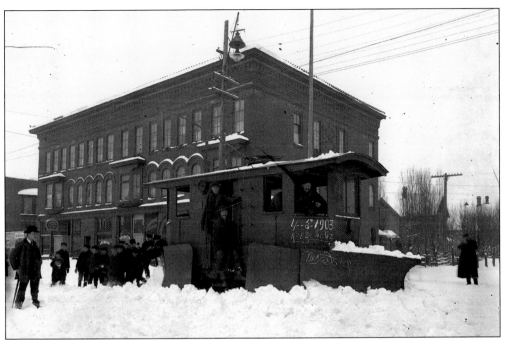

Dealing with the copious snow provided abundantly by the lake effect from frigid Lake Superior winds, the Houghton County Traction Company was forced to develop special snow equipment such as this unique double-ended traction plow. An Adolph F. Isler photograph, it is marked April 5, 1903, and was taken in Red Jacket, as Calumet was called at the time. (MTU Archives and Copper Country Historical Collections, Michigan Technological University.)

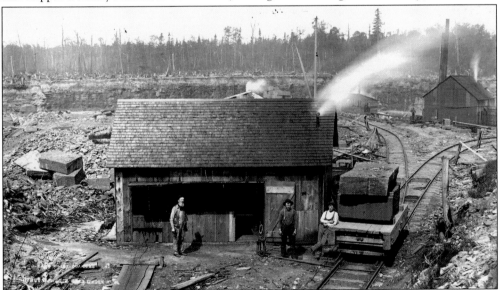

This Adolph F. Isler photograph of the Portage Entry Redstone Quarry was taken on June 1, 1911, and shows the tremendous size of the slabs of red sandstone that came out of the quarry. They were sent down to the docks on the gravity rail line to be loaded on ships and sent down to Chicago, Detroit, New York, and points south for decorative construction purposes. (MTU Archives and Copper Country Historical Collections, Michigan Technological University.)

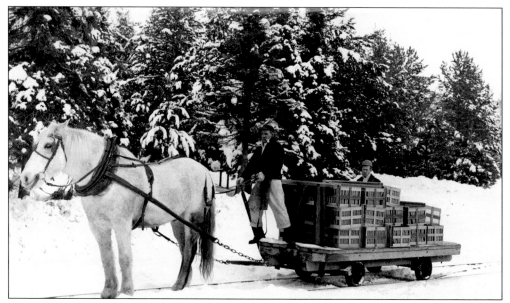

As shown in this January 1953 snow scene, to avoid the chance of sparks from a locomotive causing an explosion, the Atlas Powder Company rail line relied totally on horsepower and manpower. The shell truck is being pulled by Pat with Andrew Gazetti at the controls and Ray Sved behind the load, keeping an eye on the slow and safe movement of the delicate and dangerous cargo. (MTU Archives and Copper Country Historical Collections, Michigan Technological University.)

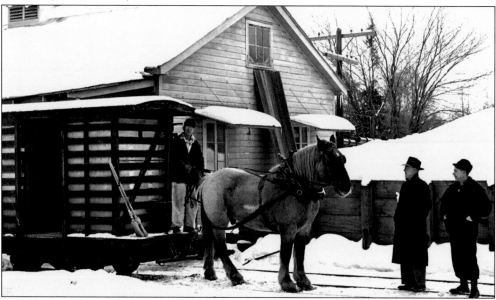

During World Wars I and II, thousands of these gunpowder cars were built by American Car and Foundry at its Wilmington, Delaware, plant, the former Jackson and Sharp car building facility. The magazine truck driver, Jack Ploof guides "Faithful Old Mike" down the powder line. In front of Mike is Atlas Powder Company manager George Barnes in the long overcoat and Otto Ristala, the powder line foreman. (MTU Archives and Copper Country Historical Collections, Michigan Technological University.)

Eight

TRAINS AND SHIPS

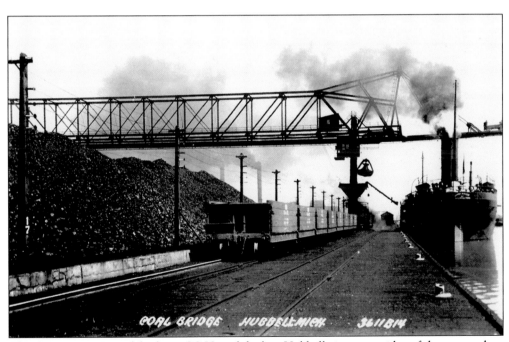

This fascinating view of the large C&H coal dock at Hubbell gives some idea of the tremendous size of the equipment used to unload the ships and load the waiting rock cars. These huge stockpiles of coal were needed to keep the C&H mines, mills, and smelters operating through the winter months when the lakes were frozen and the freighters could not bring in supplies. (David D. Tinder, William L. Clements Library.)

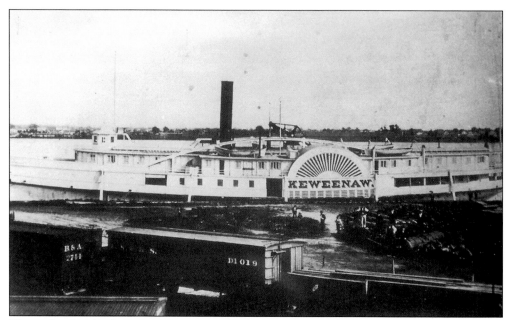

The early side-wheel steamer *Keweenaw*, which is seen here with the Lake Shore and Michigan Southern Railway cars in the foreground, plied the waters of the Great Lakes for many years carrying passengers and cargo to and from the far reaches of the Great Lakes from Cleveland on Lake Erie to Duluth on Lake Superior for its owner, Eber Ward of Detroit. (George E. Anderson collection.)

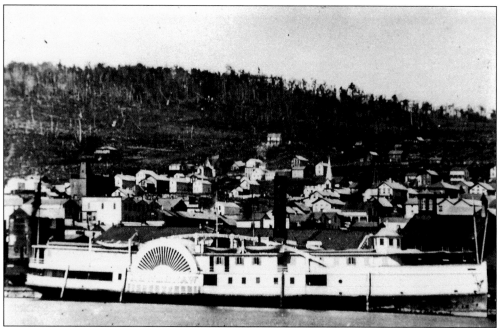

This scene shows the early side-wheel steamer *Keweenaw* in Duluth, at the far northern end of its ambitious route through the Great Lakes. Guided by Capt. Albert Stewart, it would take one day to get from Cleveland to Detroit and another six days of travel to get to the farthest points of Lake Superior to the ports visited in northern Wisconsin. (George E. Anderson collection.)

1868. 1868.

STEAMER KEWEENAW

Capt. ALBERT STEWART.

For Superior City, and all other Lake Superior Ports.

LEAVES CLEVELAND.		LEAVES DETROIT.	
Wedns'y Eve., May 13	Wedns'y Eve., Aug. 5	Thrsd'y Eve., May 14	Thrsd'y Eve., Aug. 6
" " " 27	" " " 19	" " " 28	" " " 20
" " June 10	" " Sept. 2	" " June 11	" " Sept. 3
" " " 24	" " " 16	" " " 25	" " " 17
" " July 8	" " " 30	" " July 9	" " Oct. 1
" " " 22	" " Oct. 14	" " " 23	" " " 15

The Keweenaw touches at Port Huron and Sarnia on the morning after leaving Detroit,

BRADY & CO., Detroit,
HANNA & CO., Cleveland, } AGENTS.

EBER WARD, Detroit, Owner,

This handbill from 1868 gives some insight into the schedule and ports visited by the early side-wheel steamer *Keweenaw*. The schedule indicates that it would take the ship at least 14 days for a complete round-trip excursion from Cleveland on Lake Erie and up the Detroit River, through Lake Huron to pass through the Soo Locks, and to Superior City on Lake Superior in northern Wisconsin. (George E. Anderson collection.)

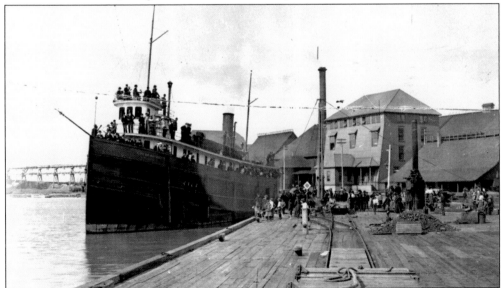

This Adolph F. Isler photograph shows the steamer *City of Marquette*, loaded with passengers, at the Lake Linden docks of the C&H mill site. The 49-inch narrow-gauge tracks of the H&TL are very much in evidence down here on the docks, and it looks like a stub switch for the turnout seen in the distance. (MTU Archives and Copper Country Historical Collections, Michigan Technological University.)

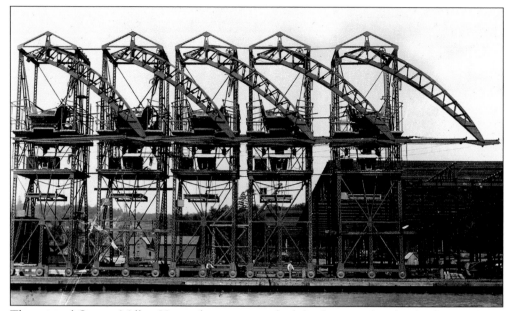

The original Quincy Mill in Hancock at one point had this battery of coal unloaders similar to the ones in use at the C&H coal docks, although these are slightly lighter in construction and bracing than the C&H structures. This same construction philosophy was evident throughout the equipment of both companies right down to the switch stands, which were fragile on the Quincy and substantial on the C&H. (George E. Anderson collection.)

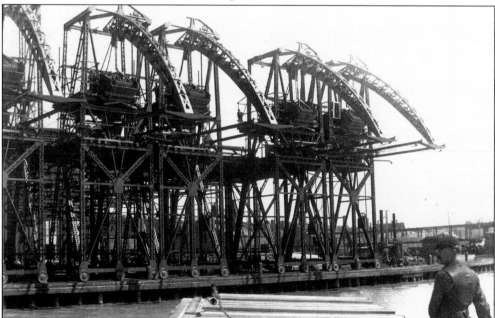

The huge coal unloading cranes located at the C&H smelter on Dollar Bay were obviously similar to those seen at the Quincy Mill in Hancock with their long curved booms and unloading buckets, but these towers were built with slightly heavier bracing and of much more substantial construction. There were five towers that traveled on rails laid on the dock to unload the ships and supply the mills. (Superior View Studio/Jack Deo collection.)

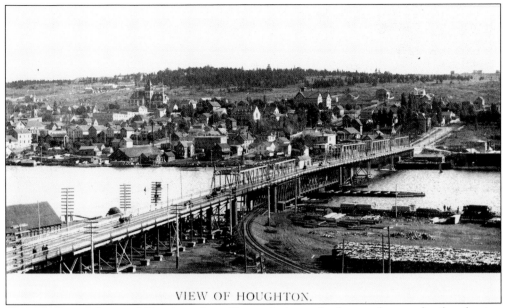

VIEW OF HOUGHTON.

An early postcard view of Houghton from Hancock shows the first roadway and railroad swing bridge built across Portage Lake. The bridge was financed by the Mineral Range Railroad around 1880 but proved to be inadequate and was replaced in the late 1890s by a joint project that provided access to the new northbound Copper Range Railroad as well. (MTU Archives and Copper Country Historical Collections, Michigan Technological University.)

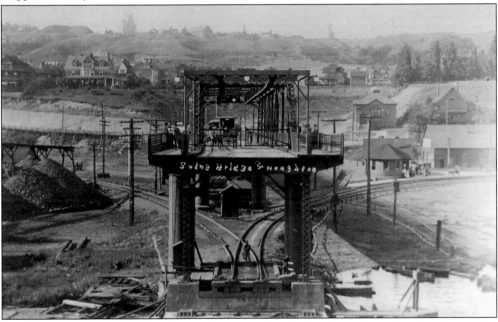

This unusual view of the Houghton–Hancock swing bridge shows the railroad tracks on the lower level and the trolley tracks, pedestrians, and carriage traffic on the upper level that have all been interrupted by a passing ship. The local children would run down the hill when they heard a boat whistle for the bridge and ride the bridge as it swung out of the way for the passing ship. (David D. Tinder, William L. Clements Library.)

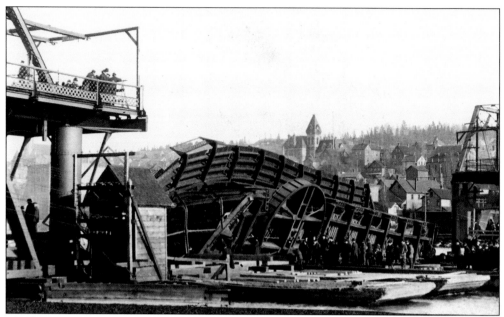

The big swing span of the Portage Lake bridge was struck and toppled into Portage Lake on Saturday, April 15, 1905, by the Mutual Transit Company steamer *Northern Wave*. The rail, pedestrian, trolley, and carriage traffic were seriously interrupted for some time until repairs could be made. This photograph from the Hancock side shows the Houghton County Courthouse in the background. (MTU Archives and Copper Country Historical Collections, Michigan Technological University.)

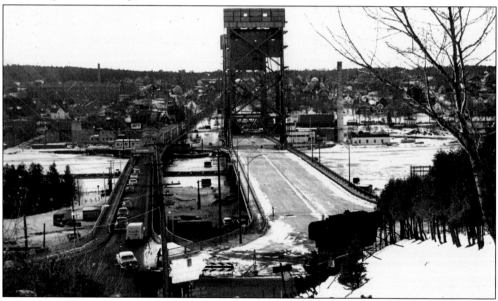

The 1902 bridge on the left is seen from the Hancock side of the lake with the new lift bridge rising next to it on the right. The current lift bridge was built between 1958 and 1959 by the Michigan Department of Transportation. It was opened on December 20, 1959, and the old bridge was completely removed by the spring of 1960. (MTU Archives and Copper Country Historical Collections, Michigan Technological University.)

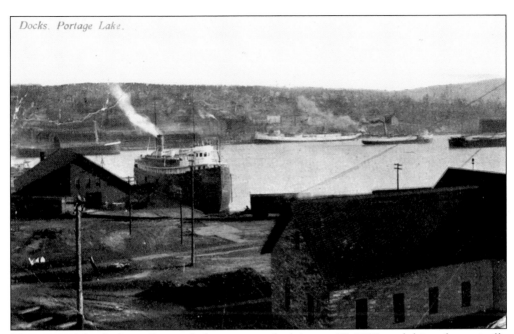

This view of the docks on Portage Lake is postmarked August 27, 1908, and shows dramatically the heavy shipping traffic on the Portage Lake and the railroads serving travelers and commerce on the docks. There are at least six cargo and passenger steamboats in this view of a small portion of the Portage Lake with many of the warehouses and train yards visible on both sides of the busy, bustling waterway. (George E. Anderson collection.)

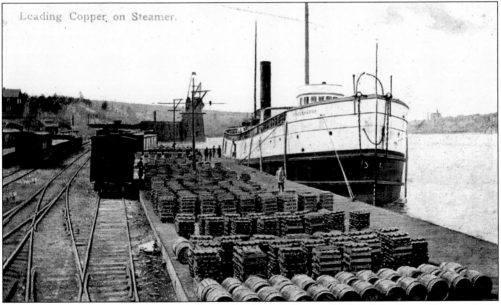

With a postmark of 1925, this card shows the Copper Range Railroad docks on Portage Lake that are stacked high with various forms of copper, ready to be loaded into the waiting steamer. The "barrel work" was pure copper chunks that did not require further processing, while the stacks of copper ingots and cakes have been through the mill to remove the rock and through the smelter to remove impurities. (George E. Anderson collection.)

117

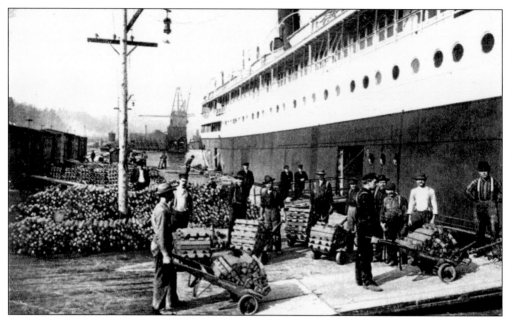

This postcard shows the labor-intensive method of loading tons of copper by hand from the railroad cars onto the docks and into the holds of the waiting steamships. It took strong backs and tremendous effort to load up those heavy carts and shove all that weight up the ramps into the cargo holds. At the coal docks in the background, they would unload and stockpile fuel for the winter. (George E. Anderson collection.)

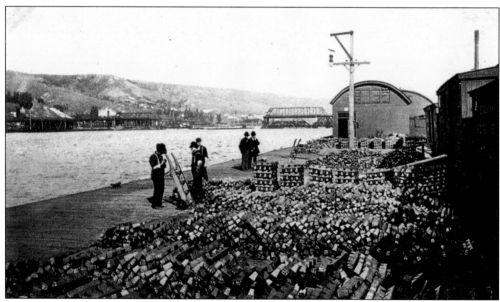

With the railroad cars now unloaded, the dock working crew has a rare quiet moment waiting by the piles of copper ingots for the arrival of a ship through the open swing bridge in the background. The ship will soon be loaded with the tons of copper ingots and dispatched back down the waterway to feed the hungry industries on the lower Great Lakes. (George E. Anderson collection.)

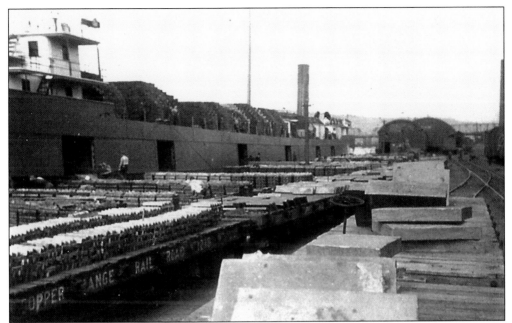

A string of heavily laden Copper Range Railroad flatcars are lined up on the dock prior to loading 1,400 tons of copper bars, ingots, and cakes onto a waiting steamship. The first car on the left is car No. 1216, one of a group of 25 cars delivered in 1906 from American Car and Foundry in Chicago as lot No. 4056. They were 36 feet long and were numbered from 1200 to 1224. (George E. Anderson collection.)

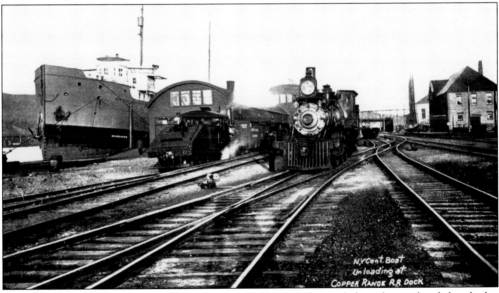

The Houghton Union Depot of the Copper Range was located directly south of the docks, parallel to the tracks headed east for the Portage Lake swing bridge. Here Copper Range No. 1 0-6-0 switcher switches the dock warehouse as a former Delaware, Lackawanna and Western Railroad 4-6-0 (No. 53 or No. 54) faces the camera in this 1904 picture. These Dickson-built 4-6-0s were later sold to the Keweenaw Central Railway. (Adolph F. Isler, Houghton County Historical Society Archives.)

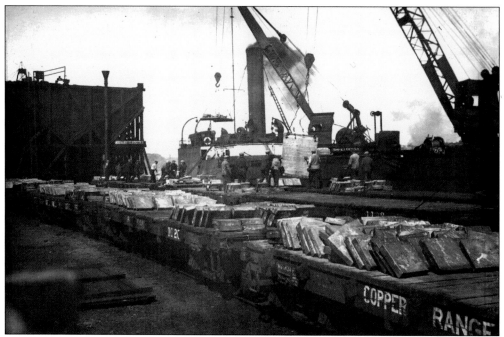

J. T. Reeder shot this photograph in 1933 of slab copper from the Mohawk Mine being loaded onto the steamer *Burlington*. The slabs were transported from the smelter to the docks on all-wood Copper Range Railroad flatcars. The coal dock and coal unloaders are behind the tracks and on the wharf. (MTU Archives and Copper Country Historical Collections, Michigan Technological University.)

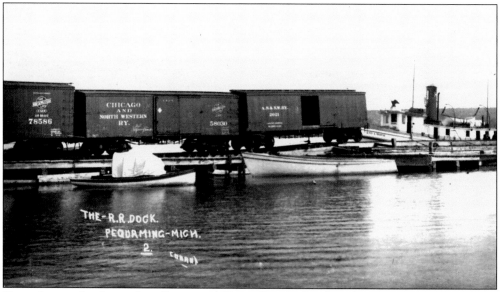

Operating on the former Iron Range and Huron Bay Railroad track, a DSS&A crew switches the docks at Pequaming in the 1920s. By this time, the big Ford Motor Company sawmill at Pequaming was in full swing and its supplies and machinery arrived, and wood products departed by both rail and water. (Earl Gagnon collection, MTU Archives and Copper Country Historical Collections, Michigan Technological University.)

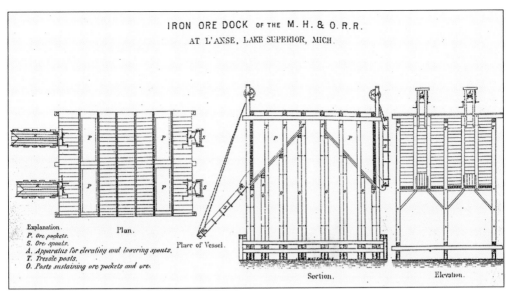

The description of this iron ore dock at L'Anse is dated January 31, 1873, and shows that the dock was 546 feet long, 36 feet wide, and 38 feet high. The ore dock has 80 vessel pockets, 40 on each side, with 4 steamboat pockets at the end. Each pocket holds 75 tons of ore and the dock can load four vessels and one steamboat at the same time. (George E. Anderson collection.)

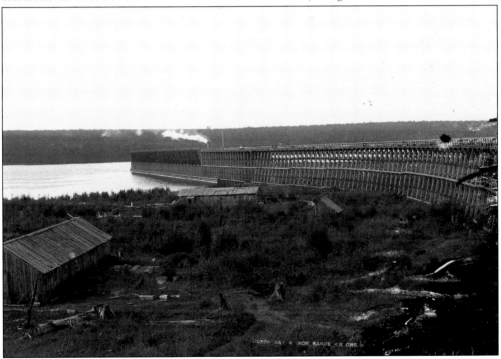

This Adolph F. Isler photograph shows the short-lived impressive iron ore dock located at the foot of Keweenaw Bay near L'Anse. The ore dock was built and served by the Iron Range and Huron Bay Railroad, which was eventually absorbed as a branch of the DSS&A. The line also served sawmills in the area, such as those eventually developed by Henry Ford at Pequaming. (MTU Archives and Copper Country Historical Collections, Michigan Technological University.)

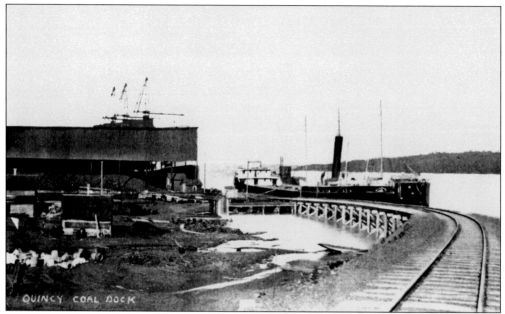

The new coaling facility at the Quincy Mill was ordered from John A. Mead Company of New York in January 1902. Quincy Mill was very proud of its new coal facilities and informed its suppliers that they should employ the largest ships possible because each tower was capable of unloading 4,500 pounds of coal per minute or 13,500 pounds of coal per minute if all three towers were used at once. (George E. Anderson collection.)

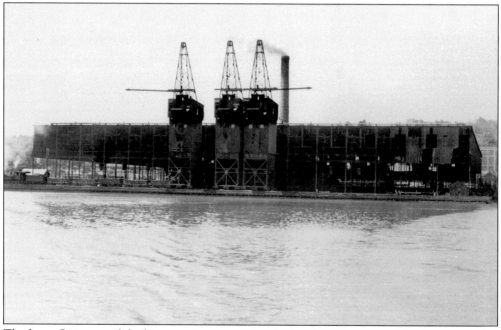

The huge Quincy coal facility went into operation in April 1902 prompted by the rates being charged by the Mineral Range Railroad and the H&C to haul coal up to the mines on Quincy Hill. Locating the coal at the mill set the pattern for the railroad to haul coal back up to the mines in the same cars that had just emptied their ore at the mill. (George E. Anderson collection.)

Nine

RAILROADS
IN THE WOODS

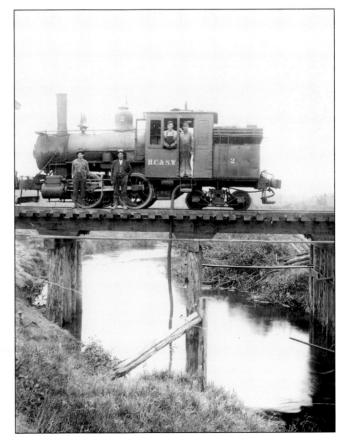

Houghton, Chassell and Southwestern Railroad (HC&SW) engine No. 2, originally Chicago's Lake Street Elevated Railway engine No. 9, a 0-4-4T Forney built by Rhode Island Locomotive Works in 1893, takes on water from a trestle over the Otter River near camp 5. The venerable locomotive has survived and was restored to its original appearance as the *Charles H.* for the rededication of the Chicago El and is now on display at the National Transportation Museum in St. Louis. (MTU Archives and Copper Country Historical Collections, Michigan Technological University.)

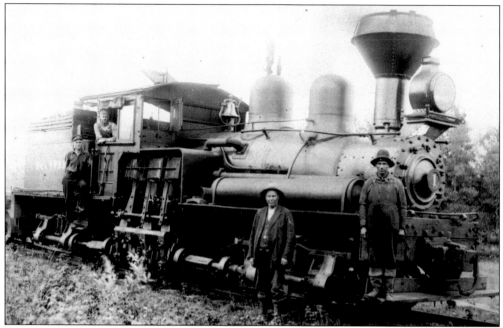

The crew poses with their engine, HC&SW No. 1, a three-cylinder Lima Shay C/N 2235, built on October 4, 1909, to standard gauge for the Worchester Lumber Company to be operated on the HC&SW. The railroad never got any further north toward Houghton than to the sawmill in Chassell but did have extensive trackage in the woods to the southwest of Chassell. (MTU Archives and Copper Country Historical Collections, Michigan Technological University.)

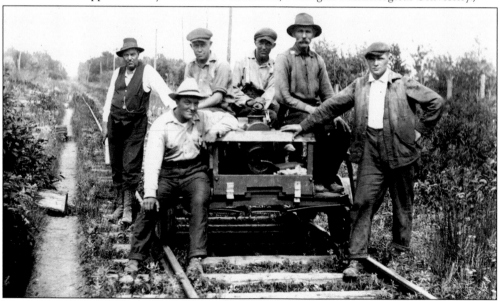

The HC&SW's small gasoline-powered railcar and its crew stop for the photographer somewhere along the line. The doodlebug was part of the rail operations of the Worchester Lumber Company, which had purchased the Sturgeon River Lumber Mill at Chassell on Pike Bay. Its standard-gauge tracks ran southwest through Worham into the woods with spurs to several lumber camps. (MTU Archives and Copper Country Historical Collections, Michigan Technological University.)

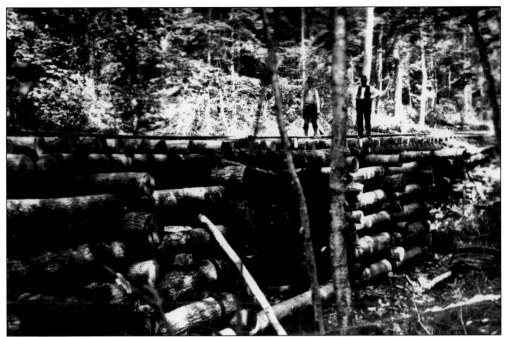

The one thing that a lumber company has plenty of is logs, and, as seen here, the HC&SW used those logs for a timber-cribbing bridge to carry the rails across a little valley out in the woods. Once the area is logged off, they will pull up the tracks and take the logs to the lumber mill to be cut up into boards. (MTU Archives and Copper Country Historical Collections, Michigan Technological University.)

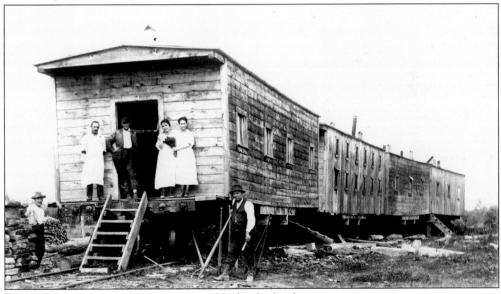

These HC&SW camp cars made it possible for the lumber company to set up operations out in the woods to harvest the trees and then easily move the camp deeper into the forest when the timber had been cut. The first car looks like the kitchen with the cooks out on the end platform, and the second car is the dormitory car with bunks for 24 lumbermen. (MTU Archives and Copper Country Historical Collections, Michigan Technological University.)

Standing in front of the HC&SW 1925 Ford Model T inspection railcar is Ken Hamar, and William Merrill is standing by the rear door. The first station on the line south of Chassell is named for Merrill, and farther down the line is the town of Worham, a contraction of the parent Worchester Lumber Company and the name Hamar. (MTU Archives and Copper Country Historical Collections, Michigan Technological University.)

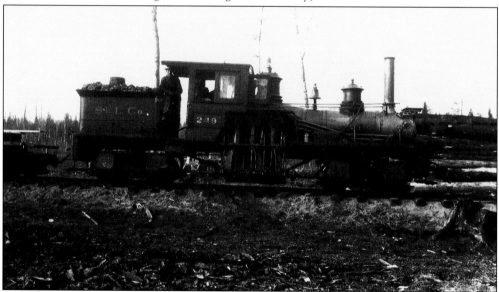

This small three-cylinder Shay was built by Lima on August 6, 1889, to 48-inch gauge. It went through other Michigan lumber companies before being seen here working for the S-K Lumber Company of Calumet, retaining its construction number, 249, on the cab as its road number. The fluted domes and slender stack on the 1880s engine seem out of place in this rough-and-tumble scene in the woods. (George E. Anderson collection.)

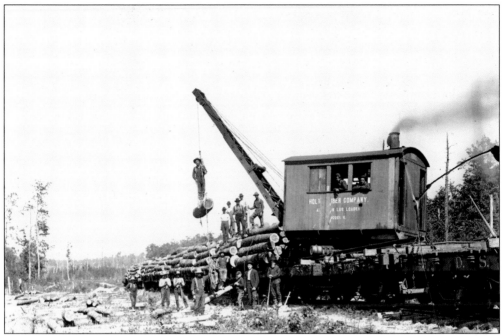

A log loader working for the Holt Lumber Company in Ontonagon County is seen loading logs onto a string of DSS&A flatcars. They did not give much thought to safety at that time, as one man is riding the log being loaded onto the cars, and another group stands on the logs already loaded, while others stand under the log being swung overhead. (MTU Archives and Copper Country Historical Collections, Michigan Technological University.)

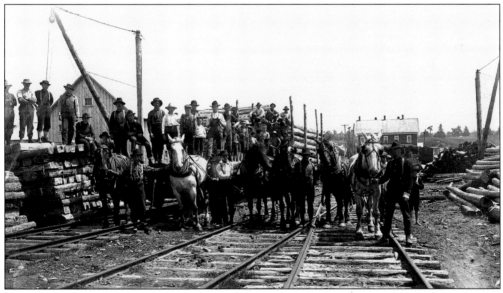

A sawmill crew pauses for a photograph while stacking railroad ties with a stiff leg derrick. Unlike the square-cut ties seen today, the mill merely cut them to length and plane-cut two sides leaving the bark on the other two sides. For the photographer, everybody, including the horses, got in on the picture. (MTU Archives and Copper Country Historical Collections, Michigan Technological University.)

DISCOVER THOUSANDS OF LOCAL HISTORY BOOKS
FEATURING MILLIONS OF VINTAGE IMAGES

Arcadia Publishing, the leading local history publisher in the United States, is committed to making history accessible and meaningful through publishing books that celebrate and preserve the heritage of America's people and places.

Find more books like this at
www.arcadiapublishing.com

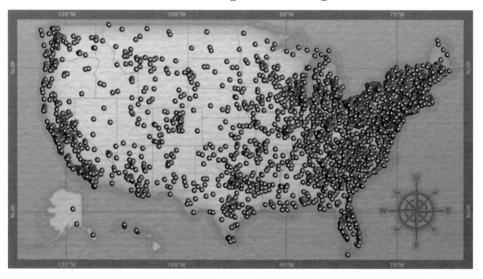

Search for your hometown history, your old stomping grounds, and even your favorite sports team.

Consistent with our mission to preserve history on a local level, this book was printed in South Carolina on American-made paper and manufactured entirely in the United States. Products carrying the accredited Forest Stewardship Council (FSC) label are printed on 100 percent FSC-certified paper.

MADE IN THE